✓ P9-DBO-545

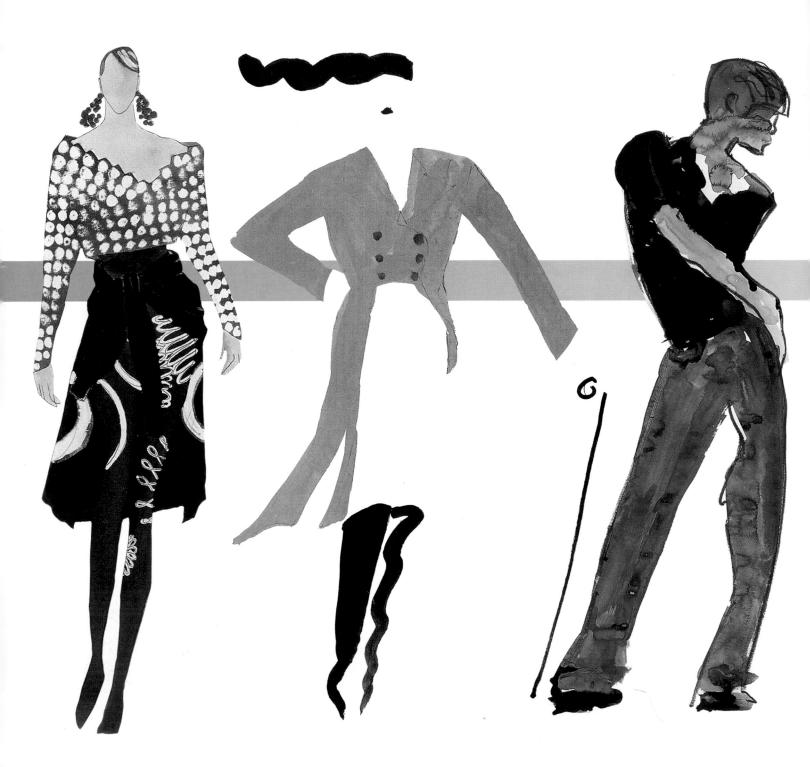

Fashion design drawing course

Principles, practice, and techniques: the ultimate guide for the aspiring fashion artist

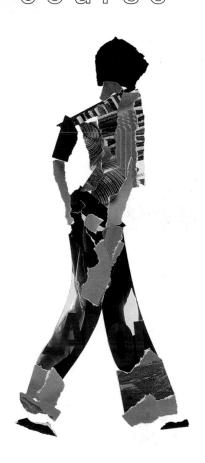

Caroline Tatham • Julian Seaman

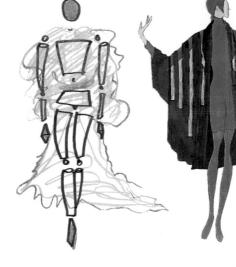

contents

Introduction
How to use this book
Assessing your work

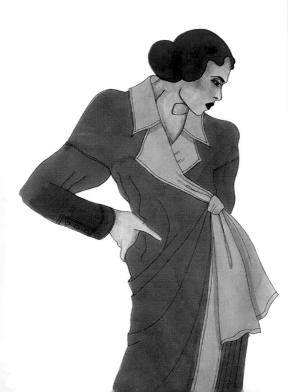

3254716030479 741.6 TAT Fashion design drawing course

BRISTOW MIDDLE SCHOOL

chapter 1

6 10 11

FINDING INSPIRATION

Inspiration file: Where to start	14
Unit 1: Visiting a museum	16
Unit 2: Investigating architecture	20
Inspiration file:	
A fresh look at the familiar	24
Unit 3: Mood boards	26
Unit 4: The traditions of India	30
Unit 5: Fine art and graphics	34
Inspiration file: Small details, big ideas	38
Unit 6: Designing fabric ideas	40
Unit 7: Starting with embroidery	44

chapter 2

ILLUSTRATING FASHION

Inspiration file:

50
52
56
58
62
66
70
74
76

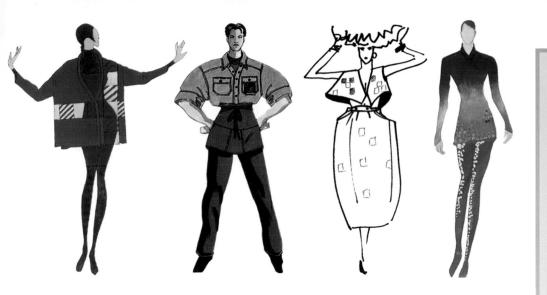

chapter 3

PLANNING AND DESIGNING

Inspiration file:

Creating a cohesive collection	82
Unit 14: Learn to love your roughs	84
Unit 15: Planning a range	88
Inspiration file: Designing to a brief	92
Unit 16: Customer focus	94
Unit 17: Occasions, seasons, budgets	98
Inspiration file: Color and fabric	102
Unit 18: Color palettes	104
Unit 19: Structuring fabric	108

chapter 4

COMMUNICATING YOUR VISION

Inspiration file:

Clarity and communication	114
Unit 20: Working drawings	116
Unit 21: Real garments for your portfolio	o 120
Inspiration file:	
Presenting your work	124
Unit 22: Practicalities of presentation	126
Unit 23: Choosing a presentation style	130
Unit 24: Presenting with flair	134

138
141
142
144

A QUARTO BOOK

First edition for the United States, its territories and dependencies and Canada, published in 2003 by Barron's Educational Series, Inc.

All inquiries should be addressed to: Barron's Educational Series, Inc. 250 Wireless Boulevard Hauppauge, New York 11788 http://www.barronseduc.com

Copyright © 2003 Quarto Inc.

All rights reserved. No part of this book may be reproduced in any form, by photostat, microfilm, xerography, or any other means, or incorporated into any information retrieval system, electronic or mechanical, without the written permission of the copyright owner.

ISBN-13: 978-0-7641-2473-0 ISBN-10: 0-7641-2473-0

Library of Congress Catalog Card No. 2002115978

QUAR.FDDC

Conceived, designed, and produced by Quarto Publishing plc The Old Brewery 6 Blundell Street London N7 9BH

Project Editor: Fiona Robertson Senior Art Editor: Sally Bond Designer: Julie Francis Photographers: Colin Bowling, Paul Forrester Text Editor: Jan Cutler Proofreader: Anne Plume Indexer: Pamela Ellis

Art Director: Moira Clinch Publisher: Piers Spence

Manufactured by Pica Digital PTE Ltd., Singapore

Printed in China by Midas Printing International Ltd.

987654

Introduction

ashion is, by its very nature, an ever-changing art. Oscar Wilde remarked that "Fashion is a form of ugliness so intolerable that we have to alter it every six months," but it is this continual evolution, the constant reinvention of old trends and the creation of new ones, that lends the fashion industry its excitement and glamor.

Fashion Design Drawing Course is aimed at aspiring fashion designers and illustrators, and anyone with an interest in the fascinating world of style. The book is modeled around the fashion courses offered by colleges and universities, with twenty-four units each containing a project to lead you step by step through the process of illustrating terrific designs. You don't need to know all about the big fashion names to take this course, nor do you need to be a genius with a paintbrush or sewing machine. The aim of this book is to unravel the mystique surrounding fashion, and to show how designs can be created through a systematic process of research and development, and the use of a range of illustration techniques. All you need to begin is enthusiasm and

a willingness to express your own unique view of the world.

No experience required

You don't need to be a sewing expert to create great fashion designs. You can explore the behavior of a made-up garment simply by draping fabric around a dressmaker's stand, and then incorporate ideas about pleating and gathering into your illustrations.

In the first chapter, "Finding inspiration," you will learn that creating a design is not a mystical affair but simply about researching, developing, and reinventing an inspiring theme. If you look at your surroundings through the eyes of a designer, you will see that inspiration is everywhere—museums, art galleries, the seashore, the city streets, even your familiar home and garden can provide you with raw material. This chapter will show you how to identify and research a source of inspiration, and how to use this

inspiration, and now to det inspiration to guide your designs, through the use of mood boards for example. It will also give

Borrowing inspiration

You can borrow motifs from paintings to create print patterns—these prints are inspired by the work of Dufy.

A stream of ideas

Use your sketchbook to explore your first ideas about a design. Don't be too critical of your roughs—just let the ideas flow and you will be surprised at the vitality of the work you produce.

Having confidence

Learning how to fill the page boldly is an important aspect of becoming a fashion designer. When you show confidence in your designs you will be well on the way to convincing tutors, clients, and employers to have faith in them too. some suggestions about how to put your own special spin on an idea, perhaps by enlarging scale to explore the unseen details of an ordinary object, or by bringing the patterns and shapes of a painting or a building into a new context, or by using your source to inspire a fabric design that will be the focus of the garment.

Once you have developed some great design ideas you need to be able to represent them on the page. The second chapter, "Illustrating fashion," will give you the confidence to expand your drawing technique to include methods such as collage and mixed media. A mistake students often make is to believe they must develop a personal drawing style early on, and then stick to it. This book encourages plenty of experimentation—if you keep pushing the boundaries, your ideas will always be fresh. Experiments don't always work, of course, but you must have the courage to fail—this is part of the learning process.

One important point to keep in mind while working through this course is that the final aim of any fashion

design is to produce a real garment that can be worn on a real human body. An article of clothing drawn on a figure that is wildly out of proportion will lack authority because no one will be able to imagine actually wearing it. The second chapter therefore explains an easy paper-folding method that an inexperienced designer can use as a guide for creating fashion figures. During this part of the course you will learn to observe carefully and to hone your representational skills, as you practice drawing people and

Capturing the mood ►

A free representation of a figure can capture a pose just as well as a very detailed one. You don't need to be a wonderful artist just be confident.

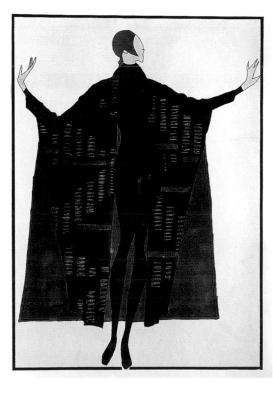

Design flavor

These presentations of garment designs reflect their Arctic source in aspects such as the Inuit-style figures and the snowflake knit pattern. Developing designs from one source produces distinctive work. garments from life. You will also learn how to be bold in your designs, filling each page with drawings that show conviction.

The third chapter, "Planning and designing," takes your design work into the wider context of the fashion industry. Being a successful designer is not about producing flamboyant one-off pieces but about developing your inspiration into a cohesive range of designs that share a strong look while offering as much choice to the customer as possible. This chapter will teach you how to work to a brief, to take into account considerations such as budget and seasonal requirements, and to build a collection aimed at a target customer whose tastes you might well not share yourself.

The final chapter, "Communicating your vision," looks at how all these wonderful ideas can be best shown off to colleagues, tutors, employers, and clients. When it comes to presenting your concepts, remember that clarity is key—there is no point in

Going wild

Designers need to be practical in focusing their work on a target customer, but sometimes it's good to let yourself go wild—this Hussein Chalayan skirt was designed around a coffee table.

▼ ► Communicating your ideas

Present your designs in an appropriate style: these jewel-like illustrations capture perfectly the sophistication of the garments. If you are studying at college, you could even take your presentation a step further by photographing your designs at the end-ofyear fashion show.

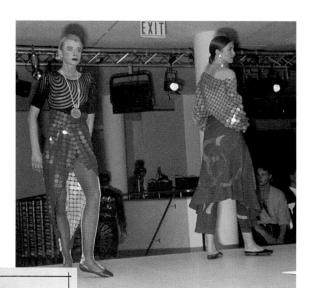

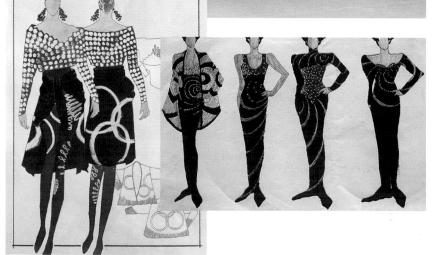

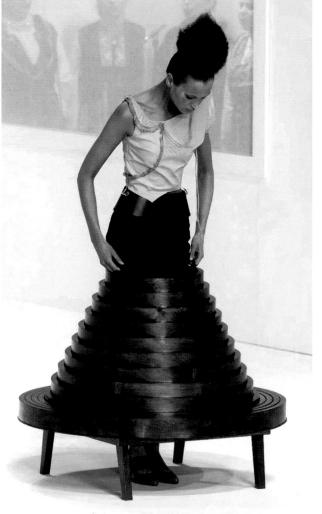

Maximum impact

You should try to present your designs with maximum creative impact. This dress was inspired by film and theater posters from the 1940s, and the concept is reflected not only in the dress itself but also in aspects such as the dancing pose of the figure and the spotlight effect created by spray paint used in the background.

Competitive business

Recently graduated fashion students have to vigorously promote their designs at shows in the hope that one of these events will catapult them to catwalk stardom.

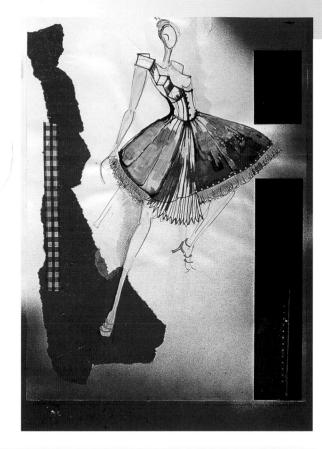

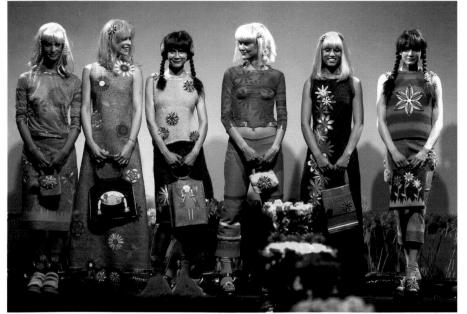

Focusing on fabrics

Sometimes a fabric idea that you have developed will be the focal point of the garment. An uncomplicated silhouette shows off a complex textile to best effect.

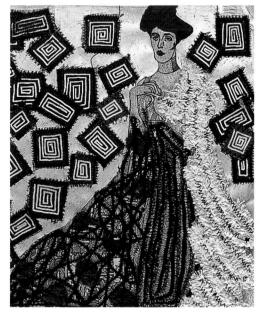

creating superb designs if no one can understand the illustrations. This chapter explains how to support your creative illustrations with flat working drawings and how to build a professional-looking presentation board. It also shows how every aspect of the presentation—from the style of drawing to the poses of the figures—can work together to communicate your vision with maximum impact.

Working through Fashion Design Drawing Course will give you the tools you need to create and illustrate designs, as well as the confidence to set off on your career as a fashion designer. Your most important assets are an open mind and a pair of fresh eyes; and remember, as you venture into this highly competitive yet rewarding business, that fashion design should above all be fun.

How to use this book

Following the format of a college course, this book is divided into twenty-four units, each one looking at an aspect of the illustration of fashion design. The units are grouped into four chapters, so you progress logically from finding inspiration to using illustration techniques to planning a collection to presenting your ideas. Throughout the book, "inspiration files" provide background information on topics approached in the units. Each unit sets a project to complete, defining the objective and describing exactly how you go about achieving it. Answering the "self-critique" questions will help you assess what you have done, and you can also compare your work to the designs in the "showcase" that completes each unit and presents successful interpretations of the project.

The project in the first **unit** is to visit a museum, introducing the reader to methods of developing a source.

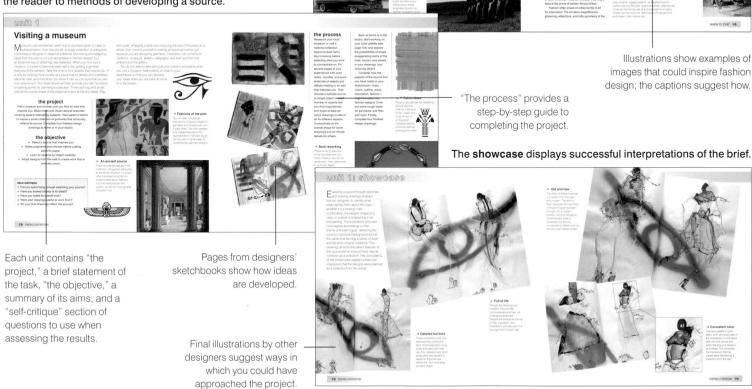

Example

inspiration file Where to start

Pages 14–19 in "Finding inspiration" contain an inspiration file, a unit, and a showcase, and provide a good illustration of the structure of the book.

The inspiration file gives an overview of the topic of finding inspiration.

Assessing your work

Whether you are a student enrolled in a course or simply working through this book on your own at home, it is essential to keep reviewing your working practice. You will not progress unless you look at your work critically, assessing whether you have achieved what you set out to do.

When you start to be artistically creative it is often difficult to judge whether what you have done is any good. Oddly, what tends to happen is that students are far too self-critical and fail to spot when they are on to a winning idea. It is always worth pursuing something that you know works for you. However, you also need to be able to ruthlessly filter out the ideas that are not working. At first, you may lean heavily on the opinion of people such as tutors, but there will come a time when you know enough about yourself and your designs to select for yourself what works and what doesn't.

In this book you are asked to carry out a self-critique on each project. Don't be too hard on yourself, but think honestly about whether your work has succeeded in the ways indicated by the questions. Here are some tips to help you with your self-assessment:

- Much of the design process has to do with self-discipline so judge your work honestly.
 You should work freely and treasure your rough ideas (they are often more exciting than an overworked concept), but you need to know which ones to reject.
- Show your work to family and friends, and accept their compliments. The most experienced designers

- might give up without any appreciation of their efforts. Even a throwaway comment from a friend such as, "I couldn't have drawn that," will spur you on to new successes.
- Don't be discouraged if other designers or members of your class seem to be producing better work than you just concentrate on developing your own unique style.

- Allow yourself to learn. Don't worry if at first your work seems very influenced by the styles of others. It is through imitation that you will discover for yourself how to make the best use of the techniques.
- Don't worry if an experiment fails. A good designer is always curious, always pushing the boundaries. It is only through trial and error that truly original ideas will emerge.
 Congratulate yourself for having the nerve to go beyond the obvious and ask yourself what you have learned from the project.
- Don't be too fixed in your definition of "success," as this will close off avenues opened up by a happy accident. So long as you know what the rules are, it can be fun to break them sometimes.
- Pay attention to your instinct about what you have produced, and don't try to judge it through the eyes of

others. Some people will love your work, others will hate it—all you can do is try to be true to your own special take on the world.

- Wind Party

chapter 1

FINDING INSPIRATION

People often wonder how fashion designers manage to come up with so many marvelous new ideas. The truth is that these ideas are rarely completely new: designers create by reinventing the world around them. This chapter will show you how to develop designs from almost any inspirational source, whether you are exploring the world of fine art or the buildings of your town, Indian culture or the familiar objects in your home and garden.

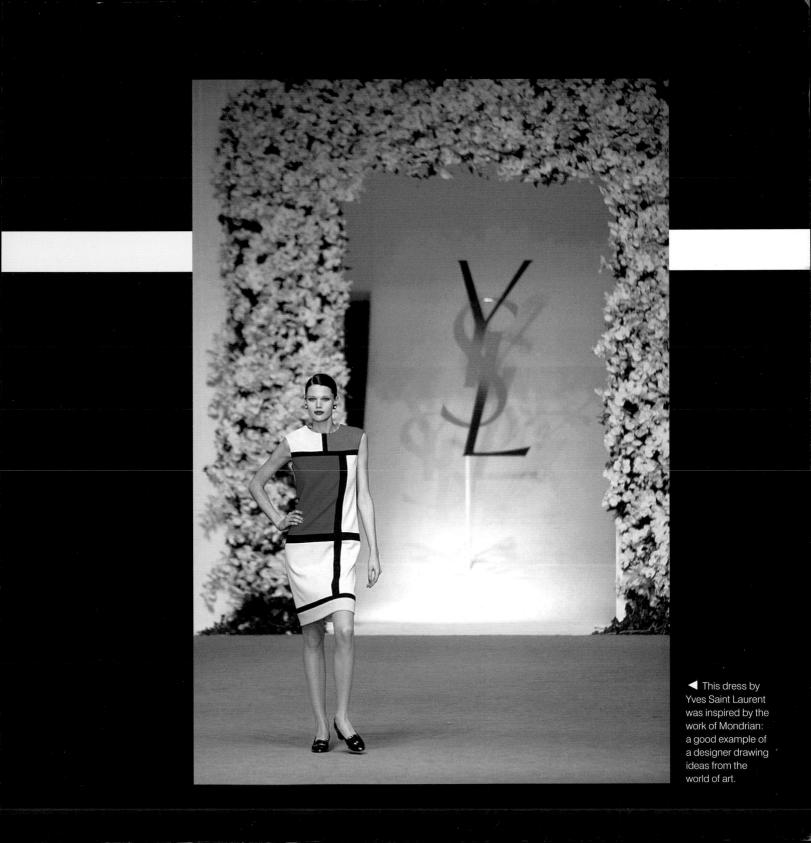

inspiration file

Where to start

One of the most daunting aspects of creativity is being faced with a blank page, but luckily ideas don't have to be spirited out of thin air. A mistake often made by new fashion students is to design a series of individual garments that have no discernible source of inspiration and no cohesive "look." However, once you have established a theme, a multitude of related ideas will come tumbling onto your page.

Inspiration for design themes can be found everywhere, whether your source is a seashell on a beach or a splendid skyscraper, the fun of the fair or the Carnival at Rio. If you research well, your topic will automatically influence your garment ideas; for example, the theme of a circus or fairground is likely to produce a colorful, flamboyant look. With an inquiring mind almost anything can trigger a creative spark. The trick is to be able to select the best route to follow. As a commercial designer you will have your customer in mind from the outset, and self-indulgent flights of fancy may have to take a backseat. As a student, however, the furthest extremes can, and should, be explored. Anything can be watered down; it is much harder to spice up something dull.

A designer should always have a finger on the pulse of the time: music trends, street culture, films, fine art movements. It is no coincidence that each fashion season has a discernible look; different designers often produce similar color ranges and silhouettes (the outline shapes of complete ensembles)

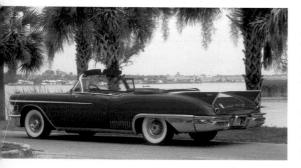

because they are all aware of the broad trends. (However, designing from a completely off-the-wall angle has also produced some of fashion's greatest moments.)

Although nothing dates more quickly than fashion, looking to the past for inspiration often produces great results. A whole era can become an inspiration, and the popularity of different eras tends to wax and wane in cycles. One year styles from the 1950s might be in fashion; the next it's a '70s look that's popular. Designs that were the height of fashion become the object of derision, only to reemerge a generation later as "must have" articles; wide-flared, low-rise trousers are a perfect example.

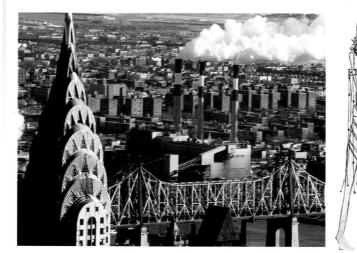

Looking up

The angled elegance of structures such as the Chrysler Building can be captured in a fashion design. Why not let a multistory building inspire a tiered skirt, or add dangling beaded ribbons to mimic the pattern of its windows?

◄► Global icons

Give a design a 1950s feel by incorporating the distinctive shape of a Cadillac's tail fins (left). The Easter Island statues (right) are also iconic: references to these enigmatic figures in a fashion illustration could have a striking effect.

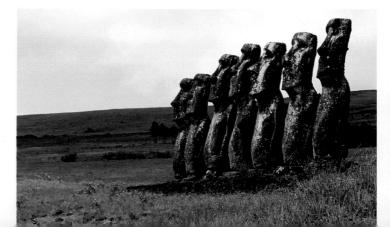

Structured sportswear has inspired many iconic shapes think football shirts and *Dynasty* shoulder pads. Cycling Lycra produced a whole new fashion concept (skintight garments in

bright colors), as did sailing wear, in the form of the synthetic waterproof clothing popularized by Tommy Hilfiger.

Patterns and styles based on ethnic ideas are recycled again and again by designers. One season they might work with the weaves of Latin American Indians; next year they might feature the prints of certain African tribes.

Fashion often draws on other forms of art for inspiration. The art deco magnificence, glistening reflections, and lofty symmetry of the

▲ Cherry-pick ideas

Once you have thoroughly researched your source, you can choose the aspects that attract you most to include in your designs. You may decide to incorporate the complex color scheme, zigzag patterns, and layered look of clothes worn by Peruvian Quechua women; alternatively, it may be the trailing coat of a circus clown or a highly ornate Carnival costume, reminiscent of tropical birds and flowers, that inspires you.

Chrysler Building in New York make it a superb example of an artistic endeavor that could easily inspire garment design. Hollywood movies can also start fashion trends; *The Great Gatsby* and the *Mad Max* series popularized, respectively, 1920s flapper dresses and the "road warrior" look that combines punk and grunge.

Your opportunities for exploring themes are unlimited. You can research ideas by visiting museums or wandering through a city to draw and take photographs yourself, or you can absorb the paintings, sculptures, films, photography, and books created by other people. The Internet is a great source of information that can be accessed from your home or college.

The knack of working with inspiration is to avoid trying to absorb too much at once. Being selective with your research and disciplined in developing just a few well-chosen themes will help you produce a focused range of designs that hold together as a collection.

Sporty shapes

The shapealtering padded shoulders of the 1980s *Dynasty* look made reference to the structured wear used for sports such as ice hockey and football.

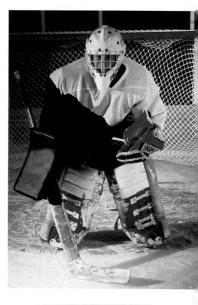

៧៣ថៃ 1

Visiting a museum

Museums can sometimes seem dull or dumbed down to cater to schoolchildren. Don't be put off; a single collection of antiquities could keep a designer in ideas for a lifetime. Borrowing and adapting ideas from the past is not just acceptable in fashion design, but an essential way of obtaining raw materials. When you first visit a museum, it is best to spend at least half a day getting a general overview of the exhibits. Take the time to find objects that inspire you. It is only by looking more closely at a piece that its details and subtleties become clear, and only when you draw it can you be sure that you are truly observing it. Your sketchbook will then provide you with hundreds of starting points for planning a collection. Think both big and small; look at the overall shape of the object and also at the tiny detail. Play with scale, enlarging a detail and reducing the size of the piece as a whole. Don't restrict yourself to looking at historical clothes just because you are designing garments. Inspiration can come from ceramics, sculpture, jewelry, calligraphy, and even just from the ambience of the gallery.

You do not need to take along all your crayons and paints when you visit a museum. Make plenty of notes in

your sketchbook so that you can develop your ideas when you are back at home or in the studio.

the project

Visit a museum and browse until you find an area that inspires you. Make notes and observational sketches covering several interesting subjects. Then select a theme to inspire a small collection of garments that obviously reflects its source. Complete four finished design drawings at home or in your studio.

the objective

- Select a source that inspires you.
- Make judgments and choices before putting pencil to paper.
 - Learn to observe an object carefully.
- Adapt designs from the past to create work that is uniquely yours.

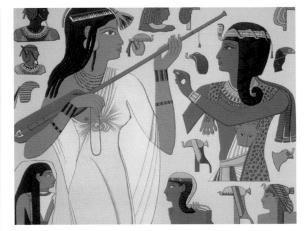

An ancient source

The monumental statues in the collection of Egyptian antiquities at the British Museum in London offer the enterprising fashion student ideas about features such as headdresses and jewelry, as well as more general stylization tips.

Fashions of the past

You can refer to historical pictures for intriguing images of garments and accessories worn in past times. The color palettes and shapes featured in this representation of Ancient Egypt can be used to ignite ideas for contemporary garment designs.

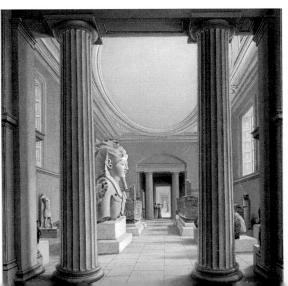

SELF-CRITIQUE

- Did you spend long enough selecting your source?
- Have you looked closely at its detail?
- Have you noted its overall look?
- Were your drawings useful to work from?
- Do your final drawings reflect the source?

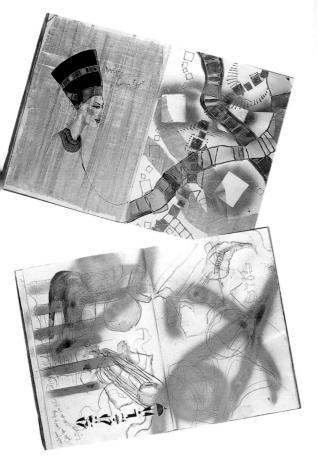

the process

Research your local museum or visit a national collection. Spend at least half a day browsing before selecting what you want to concentrate on. Fill several pages of your sketchbook with color notes, doodles, and quick sketches of objects and details relating to an area that interests you. Then choose a suitable source (a single object or small number of objects that you find inspirational) and make at least ten quick drawings on site of all its different aspects. Concentrate on the overall shape for some drawings and on minute details for others.

Bold reworking

These working drawings show how sketches and notes made on site can be developed. Here, references to gold and jewels, hieroglyphics, and stylized eyes are mixed boldly, giving a modern feel to the work.

SEE ALSO

- Mood boards, p. 26
- Color palettes, p. 104
- Designing fabric
 - ideas, p. 40

Back at home or in the studio, start working on your color palette (see page 104) and explore the possibilities of shape, exaggerating some of the lines, blocks, and planes in your drawings, and reducing others.

Consider how the aspects of the source that you have noted in your sketchbook—lines, colors, outline, mass, decoration, texture might translate into fashion designs. Draw out some rough ideas for garments, and then add color. Finally, complete four finished design drawings.

▲ ▼ Fabric ideas

Papyrus (above) has an interesting texture, and the

charms in the form of fish, shells, and locks of hair on an Egyptian necklace (below) could be used as striking print motifs.

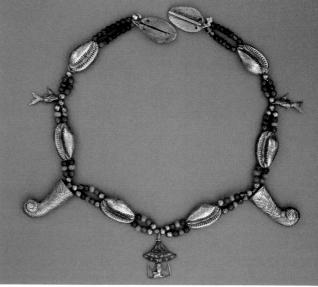

unit 1: showcase

xploring a source through sketches and working drawings enables fashion designers to identify what really excites them about the topicwhether it is a striking color combination, the elegant shape of a vase, or a detail of a fastening in an old painting. The illustrations pictured here explore and enlarge on the theme of Ancient Egypt, reflecting the source's historical background and at the same time forming a series of fresh and dynamic original creations. The drawings all echo the salient features of the source and as a result have natural cohesion as a collection. The consistency of the limited color palette furthers the impression that the designs were planned as a collection from the outset.

Though the drawings are finalized, they still feel unconstrained and free, full of life and movement. Despite the traditional source of their inspiration, the illustrations are executed in a very light and modern way.

Detailed but bold

These illustrations work well because they combine a bold, broad approach using spray and wash paint with very fine, detailed lines. Gold spray paint was applied to depict an Egyptian eye before the main illustrating process began.

Old and new

The effect of these drawings is a vibrant mix of ancient and modern. The work is fresh because the inspiration of Ancient Egypt has been brought into a modern context, not only through a contemporary style of illustration but also by incorporating details such as the very high-heeled shoes.

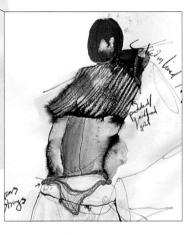

" lifting chim Hat

top of the

Consistent color

The color palette of gold, black, pink, and blue used in the illustrations is consistent both with the source and within the group of designs as a whole. This increases the impression that the pieces were planned as a collection from the start.

unit 2

Investigating architecture

I t may seem a little surprising to use buildings as inspiration for clothes. Building design is obviously meant for a long visual life, whereas fashion in clothes changes with each season. However, both forms are three-dimensional and structured, and whether it is in the overall theme of a building or just a detail, useful ideas are there to be found. A good designer needs to be a constant observer and lateral thinker. If you set out to investigate architecture, you will discover a wealth of interesting textures, subtle colorways, and strong design features, which reflect their source but also emerge as design concepts in their own right.

Whether you choose to study a historical building like a church, a famous modern landmark, or even your own home, ideas will emerge if you observe your source closely. The reflective glass of a skyscraper might suggest the use of a shimmering modern fabric; the peeling paint of an old beach hut could stimulate you to create a look incorporating ripped layers. Alternatively, let the arcaded columns adorning the Leaning Tower of Pisa evoke intricate sleeve details or bodice lacework. The perspective lines of a building often provoke ideas about outline—think how the Guggenheim Museum could suggest a billowing blouse or the art deco stylization of the Chrysler Building might be incorporated into a tiered silhouette.

the project

Think in general about the sort of architecture that could spark some design ideas. Select a building and make extensive drawings in your sketchbook. Highlight the elements (such as overall shape, design details, and surroundings) that get you thinking. Take photographs. Then make photocopies of your research and work into them using paint, crayon, and ink. Distill these ideas to illustrate four design ideas.

the objective

- Practice observing meticulously everything around you.
- Make judgments about the elements you want to use in your designs and those you choose to reject.
 - Use one form of creative work to create another.

Bold statements

The Leaning Tower of Pisa, the Sydney Opera House, the La Boca waterfront of Buenos Aires, and a glass skyscraper are all stunning examples of architecture that could inspire fashion design.

First fashion ideas

Use your first rough drawings to explore the shape of the building as a whole. The fashion parallels, such as a long flared dress or skirt silhouette, will become apparent.

✓ ▼ Deconstruction

Consider the structure of the building in depth. Exploring the jointing details, for example, may inspire you to think about how the different parts of your garments will fit together. Try to match the colors and textures of your photographic research so that your fabric ideas reflect the source, too.

the process

Start by looking through architectural magazines. Onwdecided what kind of architecture might inspire you, go

out with a sketchbook and camera to select a building and record its shape and details. Look at stairwells, elevator shafts, windows, doors, decoration, colors, and textures, as well as at the overall shape. Record the building's surroundings, too. Take photographs to capture the whole picture and make sketches to highlight the elements you want to remember. By making these choices vou will soon learn to discern what is of use to you and what to reject. Take photocopies of your photographs and sketches, which you can then work into with paint, crayon, and ink, altering the image by manipulating certain elements to create something personal to you. Finally, combine these highlighted elements into four original fashion designs. It doesn't matter if the result is a million miles away from your starting point—the cables of a

SELF-CRITIQUE

- Did you start with an interesting building?
- Did you make notes of the building's major themes and also of its details?
- Have you transformed one type of threedimensional design into another?

suspension bridge might have become cords supporting a silk bodice in your reworking of the concept—provided that the journey from source to conclusion is mapped out in your research.

SEE ALSO

- A fresh look at the
- familiar, p. 24
- Working drawings, p. 116

unit 2: showcase

hether it is the splayed lines of a railway V station that inspire a sweeping pleated skirt or the curlicue work on a wrought-iron balcony that generates ideas about embroidery or ruffles, the inspiration for garment silhouettes and details can be found in almost any architectural source. When looking for fashion ideas in architecture, it is important to explore as many aspects of the starting point as possible. It may be an unexpected detail—such as, in this case, the arrangement of windows in a skyscraper-that becomes one of the salient features of the design. The illustrations featured here distill the gathered research into unique garment designs and move away from obvious references to the starting point while still retaining a sense of the original source.

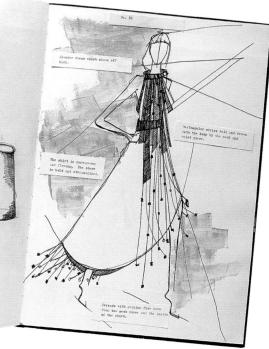

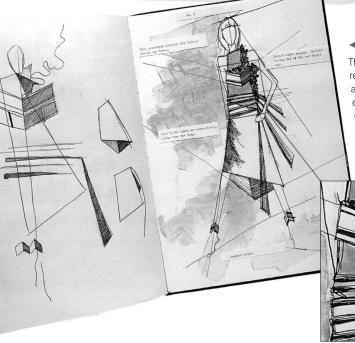

A Outline and detail

These designs are based on a skyscraper and reflect both the form of the building as a whole as well as its details. The architectural outline is expressed in the lean, angular shape of the designs, and details are shown in aspects such as the ornamentation hanging on ribbons, which reproduces the regular pattern of the skyscraper's windows.

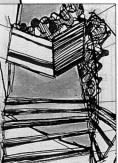

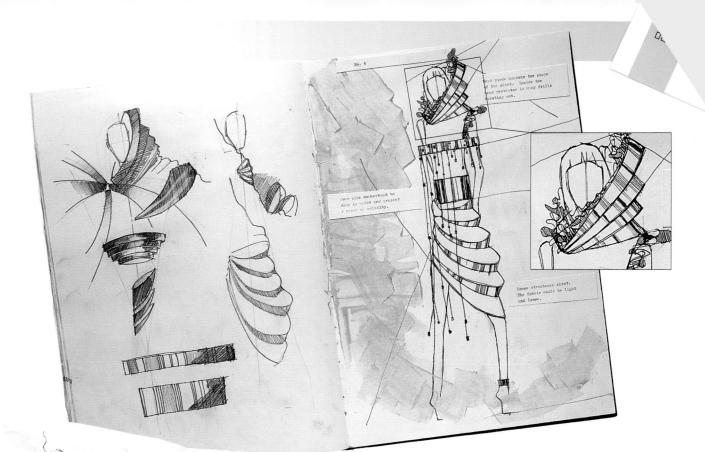

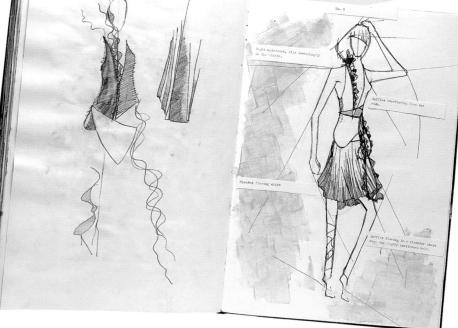

▲ The "genes" of the idea

These illustrations deconstruct the building, abstracting inspiring elements. In the process of developing a hard-edged design into the softedged format of a garment, the obvious references to the skyscraper have been lost. However, a strong sense of the parentage of the original source remains—the "genes" of the idea are still present, giving cohesion to the collection as a whole.

Using minimal color

The collection is also given a unified feel by a dynamic illustration style and the effective use of minimal coloring. The understated palette of gray, black, and a hint of red reflects the original architectural source.

Inspiration file

A fresh look at the familiar

When discussing how fashion designers and illustrators work, people often wonder where all the ideas come from. How can a designer produce such a volume of original work each season, apparently out of thin air? The answer, of course, is that it does not just appear as if by magic but comes from the systematic development of ideas often triggered by the everyday world that surrounds us.

As a designer you will learn how to look anew at commonplace objects and themes, and see in them possibilities for inspiration and creativity. Once this is understood, the mystery is exploded and you can see how the world around you offers an endless source of imaginative potential.

This huge range of choice may appear somewhat daunting at first, but you will soon develop the ability to be selective with your starting points, based on their potential value to you as a source of inspiration. The key is to use images that truly interest and inspire you, and to investigate these concepts in an original way. An exciting personal approach to a concept will add a unique flavor to a design. With time, you may find yourself revisiting certain ideas and images. This is perfectly acceptable so long as you are able to find an original interpretation of your theme

for each range of designs, and it is part of the natural development of your own recognizable design style.

As well as being of interest to you, it is important that your sources incorporate various factors that you The smallest detail Taking close-up

photography or drawing

small objects like shells will make

you notice tiny details, such as spirals and swirls,

that you can use to good effect in your designs.

▲ The natural world Embroidery or lacework ideas can be derived from something as mundane as peeling rust or the skeleton of a leaf, and the undulating lines of freshly worked hills could be translated into stripes on a billowing blouse.

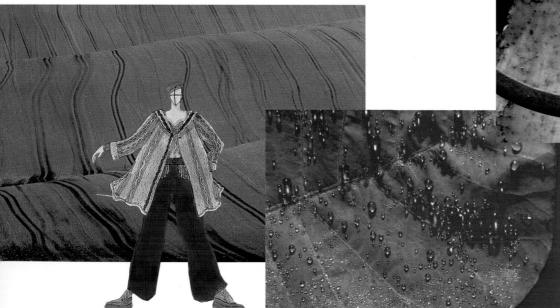

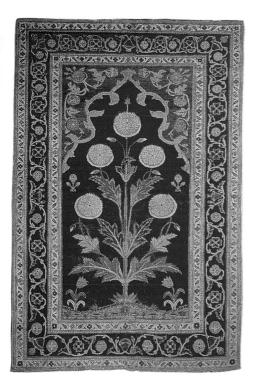

will be able to use later in your designs. The following aspects should be considered: colors and how they are combined; texture; proportion; shape; volume; details; and decoration. Your starting point should satisfy your creative interest on as many of these levels as possible. You can then use your material to create mood boards (see page 26), which will provide a focus for the further development of selected aspects of your research and help you to be disciplined in designing garments based on a few wellchosen and targeted themes.

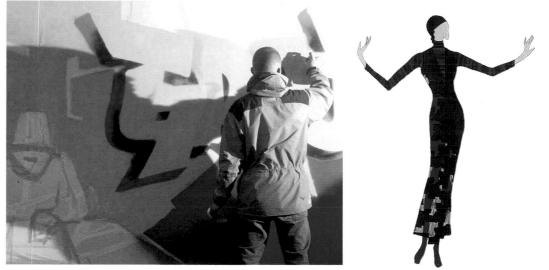

▲ The treasures at home

What interesting artifacts do you have stashed away at home? Look closely at an heirloom or a souvenir in order to appreciate it anew. Antique textiles, with their intricate patterns and rich tones, are a great source of inspiration and can be easily investigated through books. museums, and the Internet.

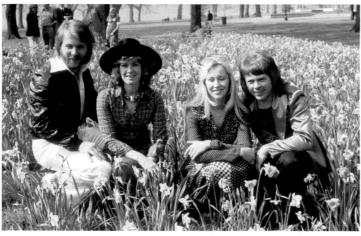

▲ Take a chance on me

Fashion runs in cycles; pop bands such as ABBA and the clothes associated with them are constantly going in and out of fashion. What "outdated" styles can be reinvented to create contemporary ideas?

A Popular culture

Street art makes a wonderful contrast to the natural world. Bright colors can inspire fantastic print ideas with a contemporary urban slant.

RI ONIGIRI ONIGIRI

Packaged culture

Packaging can be very evocative of the culture from which it originates, providing a compact set of colors, images, and graphics that can convey the essence of an entire country.

IRI ONIGIRI ONIGI

unit 3

Mood boards

Creating a mood board is great fun and will help you be selective with the research you have gathered. This is the first stage of organizing your thoughts and collected images, enabling you to channel your creative excitement toward a cohesive and targeted design outcome. Mood boards are made by arranging images and color ideas on a large board so that you can see at a glance how your designs might evolve. They vary in their complexity but, as the name suggests, mood boards should always capture the mood or flavor of your design project, as well as reflecting your target customer.

In grouping your researched images you will have to make decisions about editing and prioritizing your selection, as well as confirming your season and color palette. Colors should reflect your chosen season soft pastels will suggest a summer story, for example but whatever the season, the color palette should be applied consistently throughout the project.

the project

Select a theme and a season for your work, and consider who your target customer might be. Gather together all your research material. Using a 20 x 30-in. illustration board as a base, arrange and glue together the strongest images, and combine them with a color palette or fabric swatches to make a collage. Also include images from current fashion magazines that suit your chosen theme. Build a mood board that reflects the essence of your design project.

the objective

- Prioritize images from your collated research.
- Reflect your target customer and chosen season.
- Bring together creative inspiration and current fashion trends.
 - Finalize a color palette.
- Create a mood board that summarizes your chosen design theme.

Color samples

Paint-swatch cards can be used to help you select a harmonious group of colors for your palette. Avoid including more than eight shades in each palette or your designs may become confused and lack cohesion.

Magazine cuttings

You should hoard a range of fashion magazines. Pick out current images that support your design ideas and include them on your mood board.

Fabric swatches

If you already have ideas about the fabrics that you will use for your final designs, include swatches on your mood board. Remember to keep the presentation clean, simple, and neat

SELF-CRITIQUE

- Have you created an easy reference tool to use when sketching your rough ideas?
- Have you reflected your season and target customer?
- Have you finalized your color palette?
- Have you used the most important images?
- Have you summarized your theme?

the process

Research a theme that inspires you, gathering items such as postcards, magazine images, and photographs. Selecting from this research will help you focus on what is important in the project. Combine this inspirational research with images and trend predictions from consumer and trade magazines, fashion web sites such as www.style.com, and top designers' web sites. Also gather images to reflect the season and your target customer (see pages 94 and 98).

Experience will teach you what size of board suits you best, but try starting with a 20 x 30-in. board that allows room for lots of images as well as swatches of yarns and fabrics, and any wording. Handwriting on a mood board usually looks unprofessional, so use

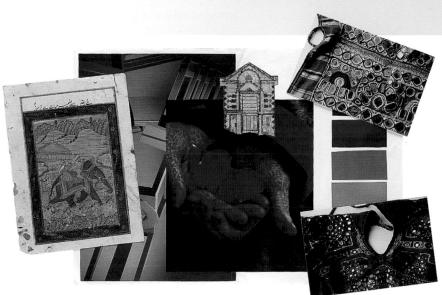

lettering or output copy from a computer.

This is a good time to try putting together a color palette to include on your board, using paint swatches, color chips from the standard color reference books produced by Pantone, or cuttings from magazines (for more information on working with color palettes, see page 104). Avoid including images that are not appropriate for your selected colors,

Refine your choice

Lay out all your gathered research material so that you can compare the images and select which to use on your mood board.

> because they will detract from the overall effect. Ensure that all the images are cut out simply and stuck down neatly. It is the images that should grab the attention and not the manner in which you have mounted them. Simplest is always best.

Test the colors

Examine your chosen images together to identify the key shades and best color combinations to evoke your theme.

Think laterally

Research widely, linking design concepts. Here, the color and carving of an ornate picture frame is visually married to intricately embroidered fabric and a luxurious sari.

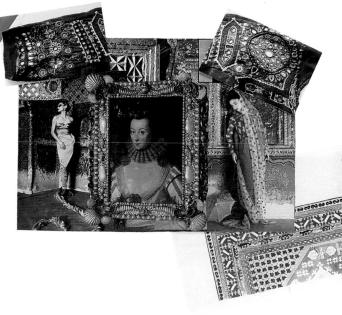

SEE ALSO

- Creating a cohesive collection, p. 82
- Customer focus, p. 94
- Occasions, seasons, budgets, p. 98
- Color palettes, p. 104

unit 3: showcase

A successful mood board, like those pictured here, has a unique personality. It expresses the essence of the design ideas and sums up the theme as well as reflecting practical concerns such as the season and the target customer. As the board is built up, combining inspirational items with pictures from magazines and information about upcoming styles, creative themes are married with current fashion trends. In this way, mood boards provide a focus for a creative yet commercial design solution.

The very act of deciding which images to include will help a designer narrow down and develop his or her ideas. As key ideas become prioritized, a clear thought process evolves and the job of producing designs then becomes much simpler. The finished mood board should tell its own distinct story—being disciplined about creating only one board per project keeps creative efforts focused.

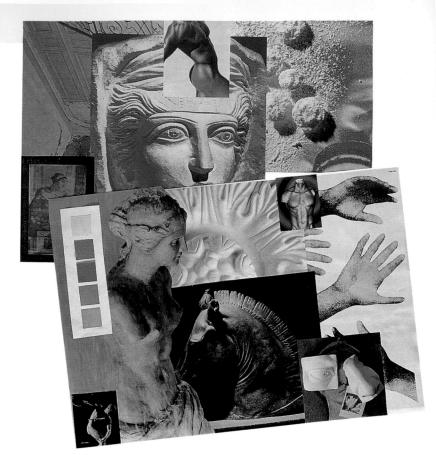

Classical inspiration

The classical theme of these boards has been inspired by the textures and forms of sculpture. A muted color palette, derived from the colors of marble, helps to evoke a timeless and restrained mood.

Seaside nostalgia

This board combines the unlikely themes of the seaside and vintage dress (particularly dress associated with travel). The final collection was called "A '20s Trip to the Seaside."

Cohesive color theming Images from fashion magazines can sit happily with research material. Here, folds of fabrics in shades of green create a common identity.

Summer colors

A high-summer decorative theme has been created in this mood board through an eclectic mix of colorful images. This selection could be narrowed down further still to focus on artists, florals, or decorative tile work.

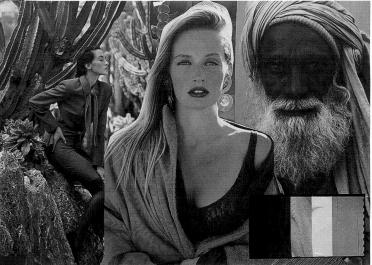

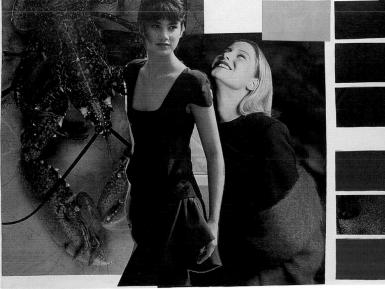

Understated sophistication
Brown and neutral tones establish a sophisticated mood.

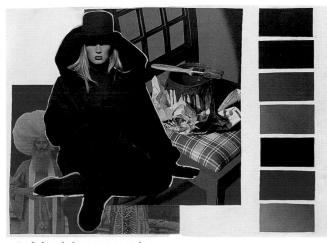

▲ A feminine approach This tonal palette of colors evokes a strongly feminine theme.

umit 4

The traditions of India

In this age of global branding, it can be refreshing to turn to non-Western cultures in search of inspiration. India is a great example of a culture that preserves a strong identity in the modern world because it is still very much connected to its traditional roots. The wonderfully vibrant colors and intricate shapes of India are a marvelous source of design ideas, whether drawn from the brilliant shades of the spices and printed fabrics, or ornate gold jewelry, or cloth woven with tiny mirrors, or the patterns of henna hand tattoos. These colors and shapes have been part of Indian culture for centuries and continue to be preserved by Indian communities around the world, so you should have no problem gathering your research.

By drawing on a source that is strongly traditional you ensure that your materials never date—because they are not subject to the whims of fashion. As a design student, you should explore as many cultures as possible; you will uncover a treasure trove of designs that with only minor adjustments of scale or color can produce

completely fresh ideas.

This project is a great opportunity to express yourself—so be as flamboyant as you like! Later in the course you will be considering issues such as customer profile and budget, so now is the time to explore some wilder flights of design fancy.

the project

Research Indian culture from as many sources as possible. Gather Indian items, find fabric swatches, take photographs, and make drawings and collages. Fill twenty pages of your sketchbook with all sorts of gathered research as well as your own work. Then start working into these found items, exploring the colors and shapes you might want to use in your designs. Restrict yourself to four finalized design drawings.

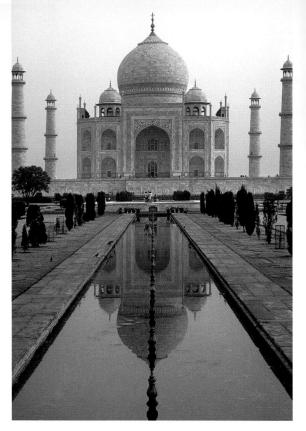

Moghul style

The fabulous architecture found in India is an excellent source of creative ideas. The dome of the Taj Mahal might suggest the full curve of a bodice, while the intricate inlay that covers its marble walls would create a stunning effect traced in silver thread on an evening gown.

the objective

- Research Indian culture to draw on the design ideas of a non-Western culture.
 - Put an original spin on these ideas.
 - Achieve an interesting mix of cultural influences in your work.

Legends of the gods

In India you are never far from the Hindu gods and goddesses, whose stories are depicted everywhere—on posters and cards and in countless films and songs. You may be inspired by the gaudy colors, the kohl-darkened eyes, or the ancient dress of these typically Indian images.

SELF-CRITIQUE

- How well have you researched Indian culture?
- Have you matched the colors and textures from your research?
- Do your finished drawings give a new perspective on the source or are they just derivative?

the process

Research Indian culture by visiting museums, libraries, shops, markets, and temples. Talk to people, buy postcards, take photographs, and make written as well as sketched notes. Look for mirrored bags, spice samples, religious icons, and makeup designs. Listen to Indian music and watch Indian films. Immerse yourself totally in the research and fill vour sketchbook with cuttings, samples, swatches, and any style directions you may wish to follow.

Once you have some ideas, start working into your research as before, first highlighting and then manipulating the inspiring elements with

paint, crayon, and ink. Try to match colors by mixing paints to achieve the perfect tone. This is harder than you might imagine, so experiment with color combinations. Try different effects, using chalk, transparent paint washes, or crayons applied lightly over dried paint, to achieve the color and texture of your source material. (When matching colors you may also find it helpful to refer to the numbered Pantone color chips. See page 104 for more details.)

Finally, complete four fashion drawings inspired by your research. Try to give them an overall look, perhaps through a uniform color scheme or silhouette theme.

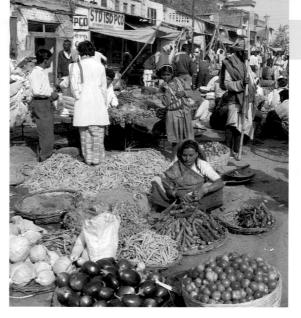

Street life

Heaps of fresh produce for sale in a street market may inspire you to try to match the glowing tones of eggplant, or perhaps to incorporate the shape of a coriander leaf into your designs.

Vibrant colors

Delicate gold jewelry or the intricate patterns of henna handpainting can be translated into textile design, perhaps using printing, embroidery, or beading.

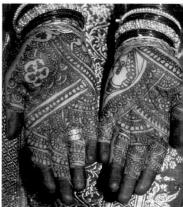

SEE ALSO

- Visiting a museum, p. 16
- Mood boards, p. 26
- Designing fabric ideas, p. 40

▼ Fill your scrapbook

Organize your research by making your sketchbook into a scrapbook and filling it with as much colorful, stimulating material as you can. Gather photographs, textual information, fabric samples, images from magazines, and any other design references that inspire you, such as examples of Indian scripts. As you arrange your research, you will begin to assemble a mood concept and formulate a color palette.

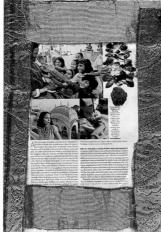

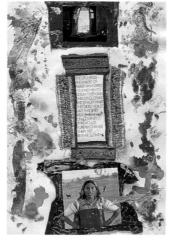

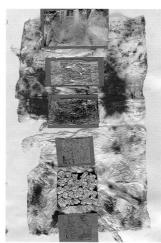

unit 4: showcase

Designs inspired by traditional Indian dress might be loose and flowing, or involve the clever use of wrapping and layering as seen in turbans and saris. The color scheme may well be boldly vibrant, reflecting the rich tones of the source material. When exploring an ethnic source, it is important to gather as many cultural references as possible so that the sketchbook research and mood inspiration gels into work that retains the distinctive feel of the subject matter without being derivative. Traditional, non-Western cultures offer the designer a wonderful source of fabric, silhouette, and embellishment ideas. However, a successful design will always put a new spin on these traditional ideas, perhaps melding them in an original way or incorporating contemporary influences to create an original concept out of an ancient design. The

> collection pictured here strongly reflects its cultural starting point while remaining essentially multicultural in feel.

▲ ► Embellishment

The use of found items such as leaves, flowers, and beads collaged onto the images gives an evocative textured feel to these illustrations.

Fusion fashion

This striking collection takes the textures and colors of India into a new context, transforming the original theme into another concept altogether. The rich, patterned fabrics and swirling skirts clearly reflect the Indian source, and the Western-style low-cut bodice contributes to the modern feel of the design.

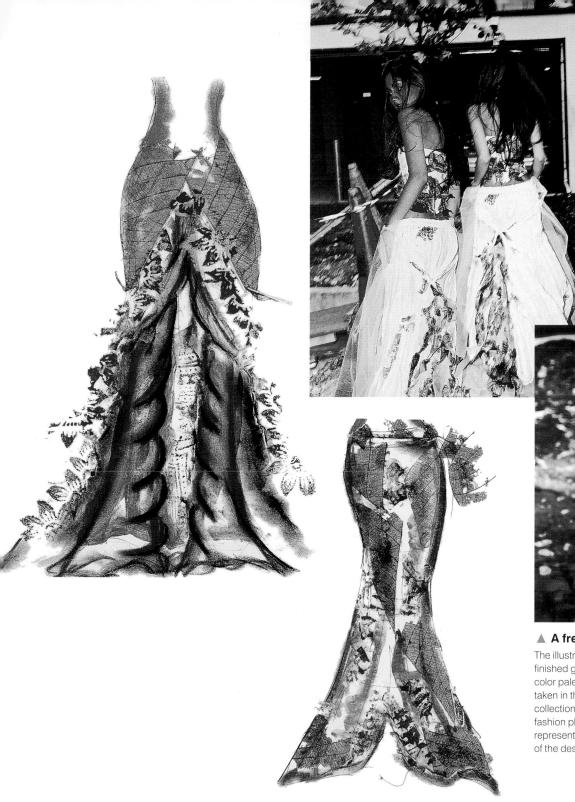

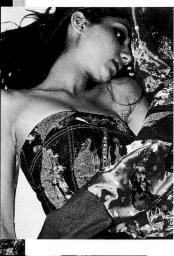

A free-spirited collection

The illustrated designs were finally made up into finished garments (with some changes to the color palette) and photographed. Care was taken in the styling of the shoot to give the collection a flowing, free-spirited feel: a fashion photograph does not have to be too representational, but it should convey the spirit of the designer's vision.

unit 5

Fine art and graphics

An important area for the fashion student to explore is print design, and one of the best sources of inspiration for this is the world of fine art. A print designer should be able to imitate the structure and style of a painting, and keep true to its color palette. Twentieth-century modernist painting provides especially rich material, as the fresh brushwork and bright colors lend themselves very well to print designs. Painters favored by textile designers include Dufy (who was himself also a print designer), Mondrian, Kandinsky, Miró, Matisse, and Picasso.

An alternative source is public domain graphic material. This is easily accessible as, for example, books or as clip-art images, available free through the Internet. Great results can be achieved by adapting and coloring these illustrations.

There are no rules about which motifs can be best repeated—in fashion print anything goes! However, if designing a print for a specific garment, you need to consider the cut of the fabric. Prints follow the fabric's grain, so cutting fabric on the bias (diagonally to the grain) will reorient the print. Also, a "one-way" print, where motifs are aligned in one direction, has less cutting flexibility than an "all-ways" print.

the project

Choose either fine art or graphic material as your source. For the first approach, try to imitate the style of a painting that you like and design five textile print patterns. For the second, rework your source material by photocopying, enlarging, and adding marks to create a square design for a headscarf. Try at least three colorways (i.e. make three versions of the design in different combinations of colors).

the objective

- Observe in detail the source material, noting colors, brushstrokes, and textures.
 - Experiment with scale and coordination.
- If you choose the scarf option, discover how a change of colorway can alter the dynamic of a design.

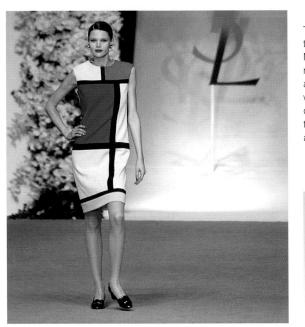

the process

If you decide to design the print patterns, research some postcards of paintings that you think may be suitable to convert into a repeatable print idea. Choose one picture, and observe its various sections and details. Then design at least five prints. Try to work in the style of the artist, taking care to use the same density of color and similar handling of paint or crayon. It can be interesting to experiment with different scales of shape and also to make

two or more designs coordinate (because the designs come from the same source, there is a good chance that they will coordinate automatically). Try designing both "oneway" and "all-ways" prints. You will be pleasantly surprised at

Creating art from art

The strong shapes and colors in the work of painters such as Mondrian lend themselves very readily to print design. Here, key aspects of the original painting were abstracted to achieve a design that refers recognizably to its source yet is itself a unique and beautiful creation.

SEE ALSO

- Investigating architecture, p. 20
- Illustrating bold print, p. 76

how many great print ideas can come from just one painting.

For the scarf project, select your graphics and make creative use of a photocopier. You can blow images right up so that the edges begin to fragment, giving an interesting texture. Then

SELF-CRITIQUE

- Could you imitate the style of your chosen painter?
- Did you make the painting or graphic your own by using it in an unexpected way?
- Did you experiment with scale and coordination?
- Are your colorways balanced?

cut out shapes and arrange them in several ways, differing the scale. These images can be juxtaposed with fine lines or other markings. Also experiment with color combinations. When you are satisfied, commit yourself to a design. Stick down the black-and-white images, and photocopy them several times to work on your chosen

colorways. You can then work into the designs with paint, crayon, and ink. It is often best not to use too many colors; by restricting yourself you simplify the process of balancing colors. You will see that making different colorways of the same design can achieve very diverse results.

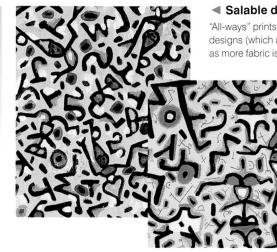

Salable designs

"All-ways" prints are usually more salable than "one-way" designs (which are less economical to use for garments, as more fabric is required to align the print correctly).

Rearranging motifs

Here, motifs were borrowed from the work of Miró and rearranged to form a loose, repeatable original print.

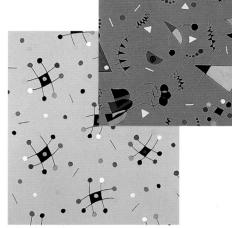

Building a design

These illustrations demonstrate a progression from graphic material to rough print design. The motifs were selected and sketches were made to test the design and the color scheme. The motifs were then arranged in the chosen design, which was photocopied to allow for the use of different colorways.

unit 5: showcase

The lines, shapes, and patterns of existing works of art and graphics can provide great inspiration for fashion designers. There isn't a painting in the world that couldn't be made to yield ten print designs, and the potential for manipulating graphic material is endless. The key to success in the first part of the project—using fine art to create print design—is to observe the works in great detail and imitate closely the style and techniques of the painter. In their bold geometric lines, the print patterns shown here have a clearly recognizable source in paintings by Dufy and Mondrian, while being at the same time original designs.

The different colorways of the scarf designs demonstrate how dramatically a new color palette changes the look of a piece. It is often best not to use too many colors; restricting the color palette simplifies the process of balancing colors and makes it easier to achieve a strong statement.

0

Repeating the motifs

Here, the work of Dufy and Mondrian has been used to create a collection of print designs. Just by taking one small part of a painting and replicating it around the page, a familiar artwork can be reinterpreted into a fresh and striking dress print design.

36 FINDING INSPIRATION

0

▲ Different colorways

The scarf prints were made in different combinations of colors, demonstrating how much a simple alteration in coloring can change the look of a design.

An integrated design

The final scarf print has been slightly altered in minor details but still reflects clearly its journey from individual graphic motifs to integrated design. The individual components have been blown up or reduced in scale, using a photocopier, to produce an interesting divergence in line strength.

inspiration file

Small details, big ideas

One simple way to see something in a fresh light is to experiment with its scale. If a small part of a commonplace object is blown up to a much larger scale, it will appear new and instead of being boring and familiar might become the source of creative ideas. It is this sort of in-depth consideration of a source that puts an individual stamp on your work.

By describing the details of an image or object in a much larger scale—through drawing, photography, embroidery, or using a photocopier—you will have already started the creative process. When experimenting with scale in this way, it is useful to try to abstract the elements that most interest you, instead of aiming simply to create a realistic representation of your topic. For example, a close-up of insect wings may inspire you to create some original color combinations or scale-like patterns. Let your series of drawings or photographs evolve to become increasingly abstract. This process of selection and development is important—you are on your way to creating a unique design solution inspired by your research.

Ask yourself why you are attracted to the images you have chosen: what is it about pebbles or snowflakes that interests you? The

Take a closer look

The most insignificant items can provoke ideas—perhaps an interesting seam detail could be based on the way these cogs fit together.

Unexpected beauty

Some man-made objects are extremely beautiful when seen up close. This circuit board might inspire ideas for beading or textured knitwear.

Inspired by science

Scientific books and magazines are a good source of ideas. In close-up images, colors are distorted and unexpected details may be revealed. Imagine how this iridescent wing could be translated into sheer fabric.

answer will point your developments in the right direction; this is what you should try to capture as you abstract out the important elements of your research. In this way, something as ordinary as paint peeling from a wall will become a wonderful mine of ideas for layers of texture and color—and you will start to see that wall through the eyes of a designer.

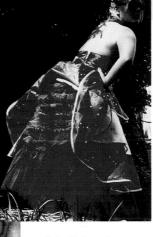

▲ Matural wonder

Nature is an endless source of shapes and patterns. The intricate folds of a red cabbage might inspire pleats of chiffon, frills, or ruffles.

▲ Layers of possibility

Repetitive man-made patterns can inspire print designs; look a little closer and layers of rust or discoloration may evoke ideas about fabric layering.

In the grain

Wood grain provides another example of nature's ability to generate beautiful and unique patterns. Here, the weather has also played its part by causing interesting cracks, which might be evoked in a design through printing, pleating, or gathering.

Inspiration underfoot

Smooth black pebbles could be investigated individually, in terms of their subtle texture and flecks of contrasting colors, or seen as a group of similarly shaped objects that could generate a random print pattern.

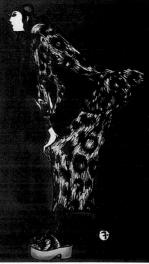

unit 6

Designing fabric ideas

The close examination of the surface detail of your source of inspiration can stimulate exciting ideas about textures and colors, which will influence your choice of fabrics. Instead of relying on fabrics that you can buy, you might decide that you want to design your own textiles, using methods such as embroidery, dyeing, knitting, or printing. These original textiles can then be incorporated into truly unique garment designs. As a general rule, when you let your ornate textile ideas take the lead, your garment designs should become simpler to let the beauty of the fabric be seen and appreciated.

the project

Choose a theme that allows the examination of detail and would be suitable to inspire interesting textile ideas. Explore your concept through drawings or photography. Use a mood board to help you select a color palette and finalize your fabric ideas. Choose the strongest textile concepts and let them inspire some simple fashion designs that display the fabric ideas in their best light.

the objective

- Select an appropriate starting point for textile development.
- Expand your ideas about creating different fabrics.
- Assess your strongest fabric concepts to inspire your rough fashion designs.

SELF-CRITIQUE

- Was your chosen source of inspiration sufficiently detailed to inspire textile ideas?
- Have you expanded from the original starting point to create unique textile designs?
- Have you used the strongest textile ideas in your rough garment designs?
- Is there a good balance between the fashion and textile elements of your designs?

the process

Choose a promising theme to research: an old graveyard, for example, offers many interesting textural details such as carved stonework, rustv railings, and layered leaves. Photography is a good way to gather research quickly. You can view your subject as an overall scene or in closeup, and the very act of looking through the viewfinder will give you a fresh perspective on the source. Then make further sketches either on site or later in the studio. using the photographs as reference. You can also digitally edit the

Rapid research

Photography is a great way to quickly gather useful research. Using a black-and-white film will help focus your mind on texture and linear pattern, whereas color photography can provide you with a good starting point for your color palette.

Group together your color photographs and create color palettes by selecting the important shades and identifying the harmonious combinations (see page 104). Alternatively, limiting yourself to blackand-white photography will help you focus on shapes and textures.

Consider how your research themes would be translated onto fabric. You can embellish fabrics through methods such as cutting, bleaching, painting, dyeing, printing, beading, or appliqué. You could even design an idea for an entirely new textile, generated through knitting, for example. Use a mood board as a focus, gathering any trims,

Creating a theme

Compiling a mood board will enable you to combine images from your research material with fashion ideas. All the selected material should work together to create a common theme or "mood."

beads, ribbons, or print effects that you may wish to use.

Finally, sketch some fashion designs that show off your textile ideas to best advantage. Remember that an intricate fabric is often best shown in a simple garment shape.

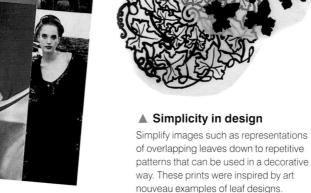

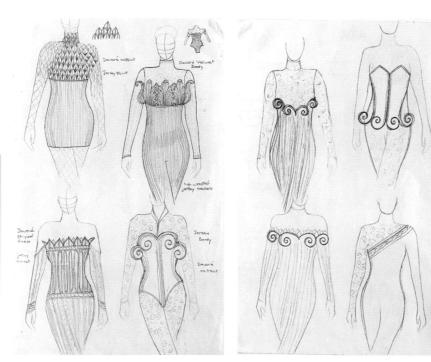

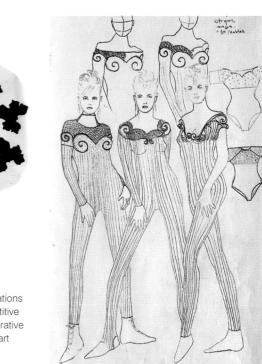

Trying out ideas

Start to sketch your rough garment ideas, incorporating fabric ideas that reflect the shapes and patterns of your research material. Try placing the fabric concepts on a figure in different scales and proportions.

SEE ALSO

- Mood boards, p. 26
- Starting with
- embroidery, p. 44
- Structuring fabric, p. 108

unit 6: showcase

Developing a fabric concept in conjunction with a garment design allows for total control of the creative process—giving a designer the opportunity to produce a truly original collection that reflects the research material in a unique way. To give designs a strong overall look, the inspiration of the source should be shown in different ways. For example, it is not just the surface treatment of the fabrics that strongly reflects the theme in the garments illustrated here—even the poses of the figures are reminiscent of the graveyard source.

Here, the simple fashion shapes are a suitable vehicle for displaying the fabric ideas. When designers invest a great deal of effort into creating a beautiful fabric, they tend to keep outlines as simple as possible. An elaborate silhouette combined with a complex textile can lead to a confused overall effect. Conversely, the illustration of the textile should not be so over-the-top that it detracts from the silhouette. For clarity, garment designs can always be presented accompanied by fabric swatches or separate textile illustrations.

Devoré design

If you have the technical know-how, you can translate your ideas onto real fabrics. Strong chemicals were used to burn the design into this store-purchased silk velvet.

Presenting ideas

Small swatches can be included on the presentation board to support fabric ideas, ensuring an uncluttered representation of the garment itself.

▼ ► Balanced designs

The style of the final illustrations can also help to evoke the source. Here the figure has been treated in a static, statuesque manner reminiscent of the graveyard sculptures. The fabric and silhouette also work in harmony: simple outlines allow textiles to speak for themselves, and the depiction of the textile does not overwhelm the presentation of the garment as a whole.

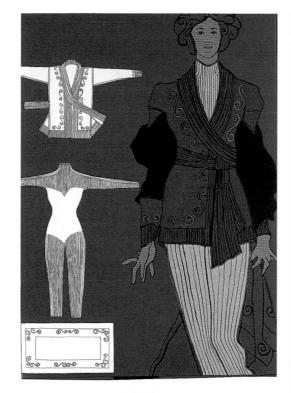

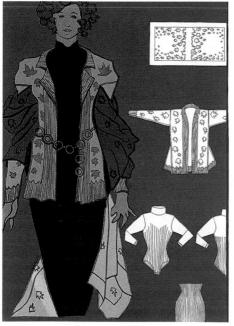

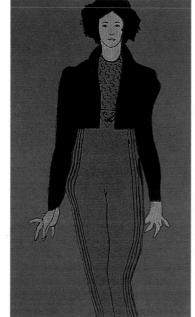

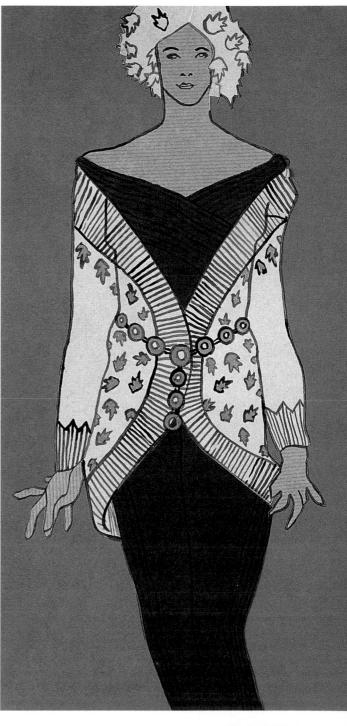

umit 7

Starting with embroidery

The previous unit demonstrates that fashion design can be driven by fabric development. In the same way, embroidery can be used as the starting point for a garment idea. You can draw on paintings for patterns and shapes to develop into embroidery designs. The artist Gustav Klimt, for example, used intricate and ornate patterns, and his work would be an ideal starting point for this exercise. You may have your own preference, but be sure to choose a source that contains sufficient decorative information to inspire you throughout your investigations. Look for shapes and patterns that can be simplified and adapted to your own design ends.

As you incorporate your embroidery ideas into garment designs, take your lead from the pages of your fashion magazines. The size, amount, and placement of embroidery used by designers tends to vary as fashion changes through the seasons.

the project

Select a work of art that you find inspiring. Explore the patterns, colors, and shapes of the chosen piece, using painting, drawing, photography, gathered research, scrapbook ideas, and fashion magazine cuttings. As you work, gradually isolate simple patterns and shapes that are easily interpreted into embroidery ideas, and use these to inspire some rough fashion designs.

the objective

- Select a suitable starting point for embroidery development.
- Combine textile and garment design by using intricate ornamentation in a fashion context.
 - Select your strongest embroidery ideas to inspire your fashion designs.

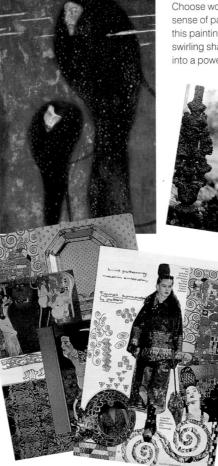

Pattern and rhythm

Choose works that show a strong sense of pattern and rhythm, like this painting by Gustav Klimt. The swirling shapes are ideal to translate into a powerful embroidered design.

◄ ▲ Widening your investigations

Original photography can be combined with research from magazines to support your observations of an artist's work. Use a sketchbook to abstract out simple patterns from your photographs. In this case, the wrought-iron railings provide a strong decorative theme.

SELF-CRITIQUE

- Was your chosen source of inspiration suitably detailed for the development of embroidery as well as fashion ideas?
- Did you let your decorative concept take the lead in the garment design, balancing intricate ornamentation with simple design?
- Have you taken the strongest ideas through to rough sketch stage?

the process

Begin by looking at a number of your chosen artist's works, but stay focused by editing down the starting points. As always, the journey of selection is vital to the design process. You might wish to combine gathered research with photographs of your own that capture a similar series of shapes and patterns. This kind of primary research adds to the originality of your design solutions-but keep it simple.

Draw or paint your own interpretations of the work, evolving these into simplified and abstracted patterns and shapes. Still working through your ideas on paper, use collage and machine embroidery to begin evolving decorative ideas. Echo the shapes and patterns that you have observed. These pieces are drawings in themselves-done with a sewing machine rather than a pen!

Begin by using the colors of your source material, but feel free to move away into your own palette. Changing colors can be a productive way to give a new twist to a familiar pattern.

Now work your embroidery ideas into some rough garment designs. Remember that a simple garment shape will show off embroidery to best effect. Pockets, collars, necklines, hems, and cuffs can all be good places to site decoration, or you might want to be bolder and place a design within the front or back bodice or on a sleeve. Decoration can be used once or repeated a number of times over the garment, in a random or engineered pattern. At this stage you should also reconsider your choice of colors and make the palette appropriate to your target customer (see page 94). Select your strongest

ideas to pull together as

the final fashion designs.

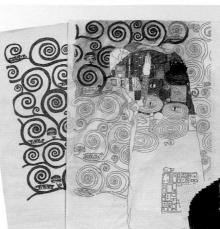

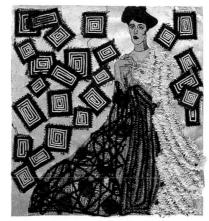

Drawing with a sewing machine

A sewing machine can become a tool for

drawing. Here, colored paper has been used to experiment with combinations of

colors and shapes.

◄ ▼ Isolating shapes

Drawing or painting your own interpretations of an artist's work will encourage you to examine your source material closely. Use your sketchbook to establish simplified repetitive patterns, derived from your starting point.

- Visiting a museum, p. 16
- Fine art and graphics, p. 34
- Small details, big ideas, p. 38
- Designing fabric ideas, p. 40

unit 7: showcase

Embroidery ideas can be translated directly onto fabric and used with fashion designs as appropriate, or they can be developed further as print ideas or textures for knitted stitches. It is possible to combine a number of these techniques, embroidering into a print idea or printing over a knit, for example. It might be that a collection contains some garments that are printed whereas others are knitted or embroidered—but they should all reflect, even if only distantly, the essential elements of the initial research.

The four final garment designs illustrated here have evolved a long way from the initial starting point,

and references to Klimt have become subtle. The finished collection has been shaped by the designer's own sense of style and reflects the source without being overwhelmed by it.

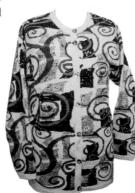

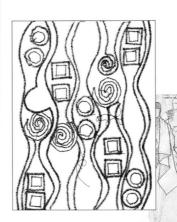

Be versatile

A set of simple patterns can be used in many different ways. For example, embroidery ideas can be echoed in knitted structures or print designs.

Themed outline

The curves and swirls of the source material are reflected in the silhouettes of the garments as well as in their embroidered decoration.

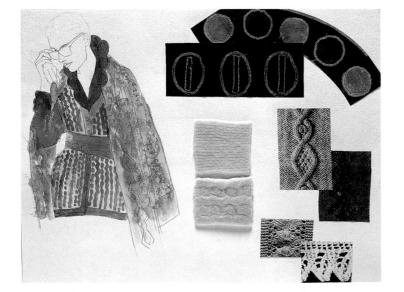

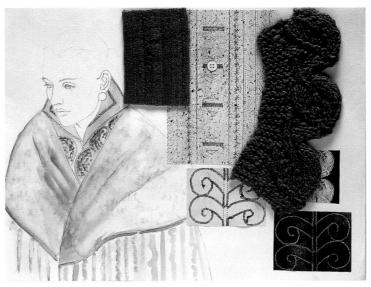

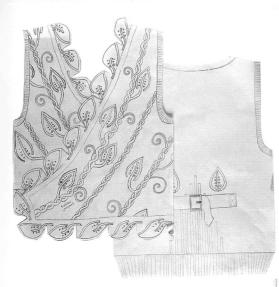

◄ ♥ Using a template

Life-size paper templates of these garments were used to finalize the placement of decoration. The embroidery designs were drawn straight onto the template.

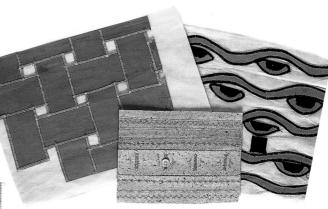

Experiments on paper

These machine embroidery designs have been tried out using paper. Simply by working on the pages of a sketchbook, it is possible to create highly original fabric embellishments.

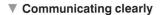

By showing the decorative detail separately from the garment itself, these four final illustrations can make a strong statement about both. Some of the embroidery ideas have been developed further into knitted textures. These designs have moved away from the original source to become strong concepts in their own right.

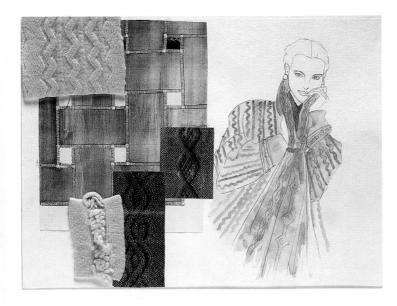

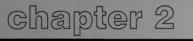

ILLUSTRATING FASHION

Now that you have developed some great design ideas, it's time to look more closely at the techniques of fashion illustration. This chapter discusses creating figures, whether through an easy paper-folding method or by drawing from life, as well as exploring the wide range of media that you can use in illustrating designs and looking at how to lay out your page effectively. Throughout this part of the

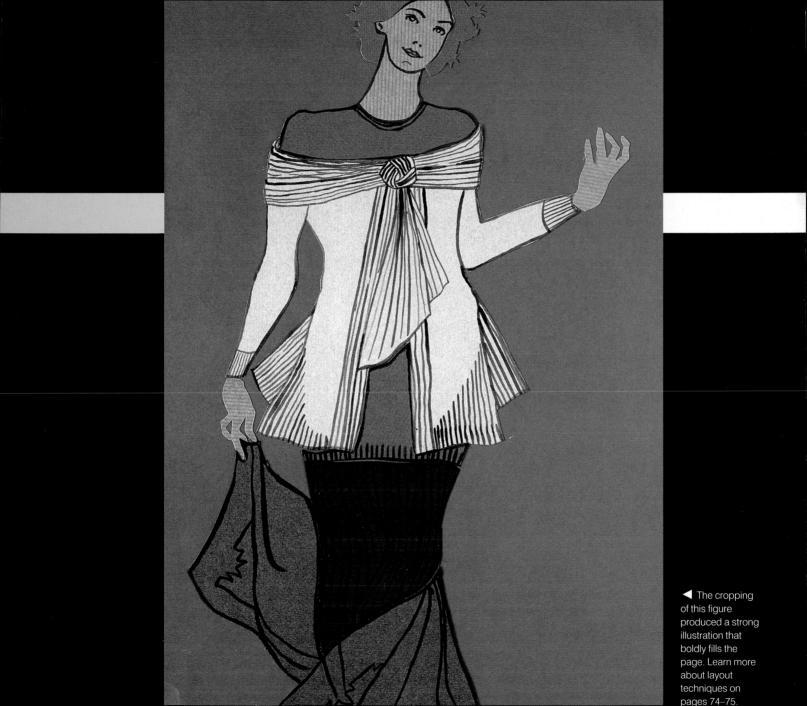

inspiration file

The human body in proportion

As a fashion designer you should always remember that clothes are made to be worn by real people. It is important, therefore, to gain some understanding of the structure and proportions of the human body.

The exercise in figure drawing described in Unit 8 will introduce you to a simple and easy system that you can use to draw figures that are roughly in proportion. The exercise has nothing to do with creativity but will help you grasp the possibilities and restrictions of the framework on which your creations will hang. There are obvious differences in the male and female forms, such as narrower waists and wider hips for females and squarer chests and faces for men. However, these variations should be incorporated once the basics have been sketched. Male and female bodies can both be broken down into

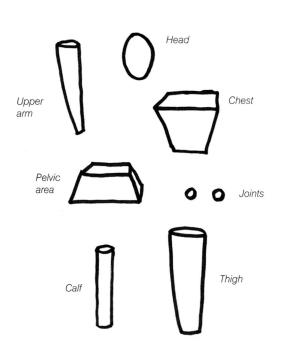

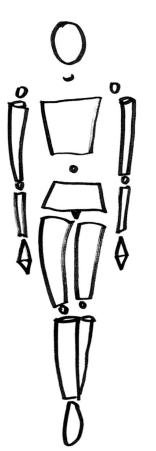

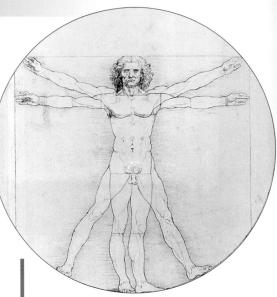

🛦 Vitruvian Man

Leonardo da Vinci is renowned for his realistic representations of the human body. He drew this illustration of a precisely proportioned figure to accompany his notes on Vitruvius. This architect wrote in Roman times that the human body is the ideal architectural model because it fits, with arms and legs extended, into the perfect forms of both the square and the circle.

Eight-and-ahalf heads

The height of a realistic human figure from crown to toe is around seven-and-a-half times the height of the head. For fashion purposes, this can be stretched (below the waist only) to eight-and-a-half head sizes. the same simple block shapes. The head can be portrayed as an egg; the chest as a wastepaper basket; the pelvic area as a wide gymnastic vaulting horse; the limbs as tapering tubes; the feet and hands as cones; and the joints as balls. Once you have drawn these shapes in the relative sizes shown (opposite), in a straightforward front view, you can move them around like parts of a wooden drawing dummy to create the pose you want. There is a convention in fashion illustration that a figure should be elongated to give it more elegance. However, that elongation should involve only the legs. A real-life body will measure around seven-and-a-half-head sizes; in fashion this increases to eight-and-ahalf heads, with the extra length added below the waist. All the other proportions of the basic block shapes should be based on reality. When you come to draw from life, a grasp of these principles will help you enormously in understanding the mechanics of the figure in front of you. It is always good to remember that these "rules" are just conventions, but by gaining a basic understanding of the structure and proportions of the human body you will be better placed to break the rules later.

▲ ► Exploring movement

A wooden artist's dummy can help you analyze movement.

A drawing based on an awareness of correct body proportions can still be free in execution and will still allow you to experiment with the presentation of the garments.

unit 8

An exercise in figure drawing

f you are inexperienced in drawing figures, using this easy method can add to the confidence of your illustrations by ensuring that your figures are roughly in proportion and all drawn to the same scale. The simple shapes and proportions of the method ensure that the figures are easy to draw and look correct. Furthermore, by grasping how these basic shapes fit together to form a human figure, your drawings will become better anchored on the page and the poses more convincing. For the sake of this exercise, the body, broken into its component parts, remains unclothed.

After you have completed the task, you should keep the drawings as a reference. You can always come back to this book, but nothing stays in the memory better than something learned by actually doing it yourself.

the project

Using a simple paper-folding method, divide your page to make a proportional blueprint of the human figure. Then draw in the basic block shapes that represent different parts of the body to make an easy-reference tool for use when you create fashion drawings in the future.

the objective

- Gain a framework to strengthen the more creative aspects of your work.
 - Practice drawing an elongated figure to use in fashion illustration.

SELF-CRITIQUE

- Have you followed this exercise step-by-step?
- Have you gained a better understanding of the basic shapes and proportions of the human figure?
- Will you be able to use this knowledge when creating fashion designs in the future?

the process

The human body is remarkably consistent in the way it divides up into sections. Make a mark just below the top of a page of paper (11 x 14 in.). Then draw a straight plumb line down the page, leaving about an inch at the bottom. and mark the end of the line. Fold your page at the halfway point between the top and bottom marks. Fold the page again, finding the halfway point on the plumb line as before, and then repeat once more. Flatten out the sheet, and you can now fill in your

proportional blueprint of the human figure.

From the top mark to the next fold draw your egg-shaped head. Divide the line between this fold and the next, and mark across the plumb line. This mark forms the base of the neck and the shoulders. The next fold indicates the middle point of the rib cage. One fold down is the navel. followed by the crotch on fold four. Ignore fold five. On fold six mark your ball-shaped kneecap, and ignore fold seven. At the level of the bottom mark, fill in the ankle with another ball shape. The

The foldedpaper method

Once you have folded your page, marking the creases as described below, you can begin to sketch in the standard body shapes to achieve a correctly proportioned figure.

gap left at the bottom of the page is for the coneshaped foot, which will protrude by about half the distance of the spaces between the folds.

You now have an eight-and-a-half-heads fashion figure that you can use as a basis for your designs. If you wish to elongate the figure further (some designers work to a nine- or even ten-heads measurement). remember that extra length should be added only below the knee. Using the block shapes, vou can then draw in the remaining body parts to fill out the figure. Draw

Using the framework

Using the "eight and a half heads" proportions as a rough framework for your illustrations will support even the most stylized representation of a figure.

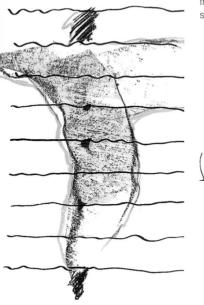

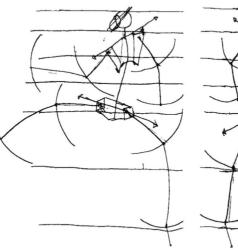

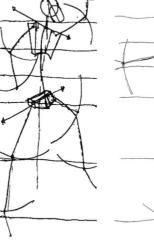

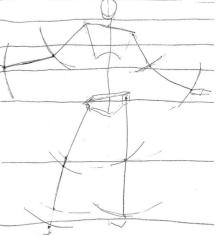

the chest from the neck base through fold two and three-quarters of the way down to fold three. Draw the pelvic box up from fold four, extending three-quarters of the way to fold three. When you add the limbs, remember that the upper arm is shorter than the lower. The elbow, with arms hanging, is just above navel level; the wrist is just below the crotch.

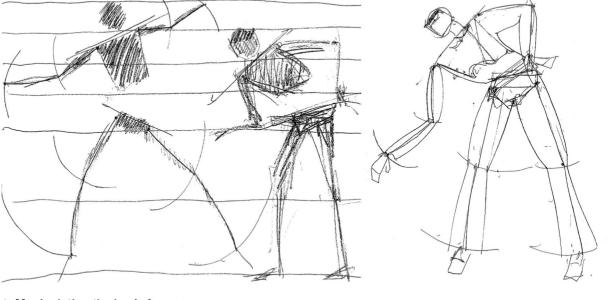

SEE ALSO
Drawing from life, p. 58

▲ Manipulating the basic forms

This sequence of drawings shows how scribbles made using the folded-paper method can be worked up into sketches for a final illustration. The basic forms remain in proportion, but have been manipulated, the limbs rotated to create a sense of life and movement.

unit 8: showcase

A lthough it is essential for a fashion designer to strive to break new ground and sometimes disregard conventions, it is nevertheless also useful to be grounded in a few basic design principles. It is important for designers always to keep in mind the fact that, whatever flights of fancy they may be exploring, their garments will eventually have to fit on a human body.

In fashion illustration it is usual to stretch the legs a little, but all other body parts should conform to their real proportions. This simple folded-paper system achieves a

pattern for a fashionably elongated but correctly proportioned figure that can then be used as a foundation for illustrations such as those pictured here. It is always possible to break completely with convention, but a student should start with a framework to support the free ideas that might follow. It is only once the basic principles have been absorbed that a designer can enjoy true artistic freedom.

Hidden structure

These figures have all been created using the foldedpaper method, but the nuts and bolts of the construction are hidden under a free-andeasy representation of the garments. A stylized depiction of garments is more likely to be successful if the viewer can accept the underlying figure as realistic.

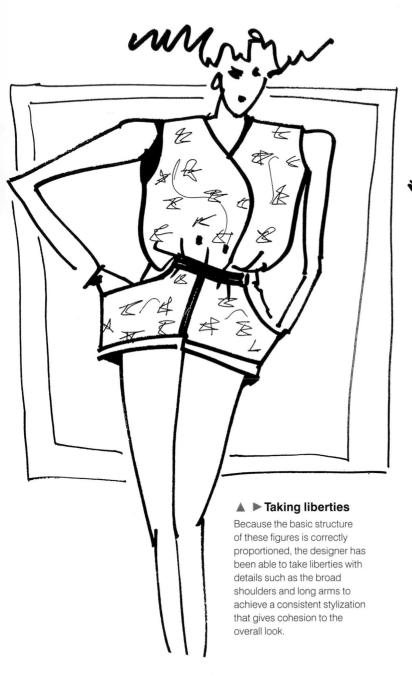

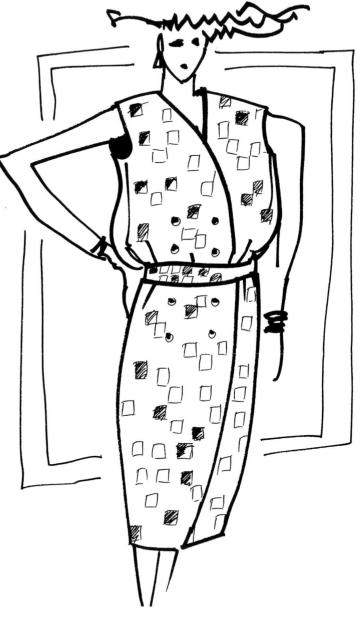

inspiration file

Experiments with media

One of the most important aspects of design drawing is the ability to "loosen up." Often a budding designer will freeze up over an important drawing, whether it's for presentation, publication, or just to show to someone else. Spontaneity is lost and any freedom that existed in the private sketchbook suddenly becomes rigid and dull.

We can all be a bit uptight about our work; let's face it, fashion is known as a somewhat uptight industry. However, a bold, flamboyant illustration is more likely to sell your concept than an overworked and nervous one, so you need to have the courage of your convictions. One of the best exercises for practicing boldness is to allow yourself a very short time to complete each illustration. Limit yourself to quick sketches, and try out as many approaches as you can. Perhaps work on a larger sheet of paper than usual. Try different crayons and paints; if by nature you prefer a thin, hard pencil, force yourself to use bright colors applied with a wet, broad brush. Even if you return to your usual methods after the exercise, the experience of exploring different media will give your illustrations an extra zest.

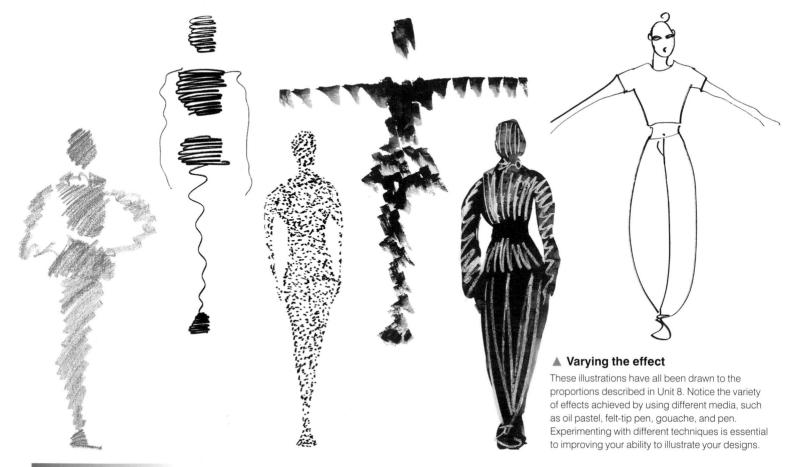

Many of these experimental attempts are destined for the wastepaper basket, but don't worry. There are so many ways of putting your ideas on paper: pen and ink, watercolor, oil pastel, conte, felt-tip pen, charcoal, poster paint, and soft pencil. These media can even be accompanied by colored paper and tissue, found textures, or cuttings from newspapers and magazines collaged onto the drawing.

One fun exercise is to quickly sketch a friend, or even your own reflection in the mirror, resisting your natural instinct to look at the page. Try drawing in a continuous line, without taking your hand off the paper. The results might be rather bizarre, but this is a good way to practice observing your subject, and expressing what you see, without worrying about how the whole picture is developing.

You can also experiment with making doodles and scribbles. These too will achieve a freedom in mark-making that will be lacking if you are too concerned with the final outcome of the picture.

These scribbles and sketches should be private. It is here that you can dare to

Gouache and watercolor paints

fail. In fact, you will not have achieved anything if all these experiments work, because you will not have tested yourself beyond the boundaries of your ability. It is only by going that bit further that you can make an exciting breakthrough. If you are really brave, you will keep the failed drawings as a reminder of your creative journey (just remember not to include them in your presentation portfolio!).

Soft pastels

Color pencils

Oil pastels and crayon

> Watercolor paints

Scissors

Paintbrushes

Craft knife

Charcoal

Graphite stick

Paint

palette

unit 9

Drawing from life

It cannot be stressed too strongly that if you are designing clothes, however exotic your sources, you must always remember that at the end of the day you are designing for a human body. Practicing life drawing is therefore a very valuable exercise that will help you observe clearly and assess quickly what you see. Using a model means you do not have to invent anything out of thin air. The information is in front of you—all you need to do is interpret it in your own individual style.

You may have the opportunity to draw from life in an art-school environment, but you can also improvise if you are working at home by asking a friend to pose. There is no need for your model to be fashionably dressed. Normal daywear with a few additional accessories such as hats, scarves, boots, or sunglasses is quite sufficient. It is more important for the class tutor, or you if you are working at home, to persuade the model to exaggerate the poses, and to change them often. Accentuation adds drama to the drawings, and responding quickly to the changing poses will bring spontaneity to your work.

the project

Spend a day practicing life drawing either in class with a professional model, or at home having persuaded a friend to pose for you. If you choose the private route, there are bound to be some giggles at the outset. That is not a problem—the exercise should be fun. Try to achieve fifteen drawings by the end of the session, spending no more than two to five minutes on each.

the objective

Make over reality in your own style.
Improve your ability to observe quickly and well.
Achieve freshness and boldness in illustration by getting the poses down on paper as quickly as possible.

 Capture the spirit of the garments while representing them graphically.

The lifedrawing class

You may well find that working with other students in the room fires up your enthusiasm and creativity—as well as giving you valuable practice in figure drawing.

the process

First spend a few minutes drawing the pose and the garment outlines in what you consider to be your own style. Be bold. Quickly capturing the pose, you have to assess the essentials and get them down on paper very fast. Avoid making feeble, sketchy pencil marks that result in tentative "hairylined" outlines.

Next, try not to look at your paper, and make a continuous line drawing, without removing the pencil from the paper. Keep the poses changing every few minutes. Now you can use some paints, choosing just three or

SELF-CRITIQUE

- Did you observe the model fully?
- Were the poses interesting?
- Has the exercise speeded up and sharpened your observational techniques?

Capturing the poses

These figures were illustrated during a life-drawing class. The limited time available to complete each pose has resulted in images that capture the essence of the garments and make a strong statement. If you do not have time to worry about getting outlines exactly right, you are more likely to achieve images that are fluid and full of life and spontaneity.

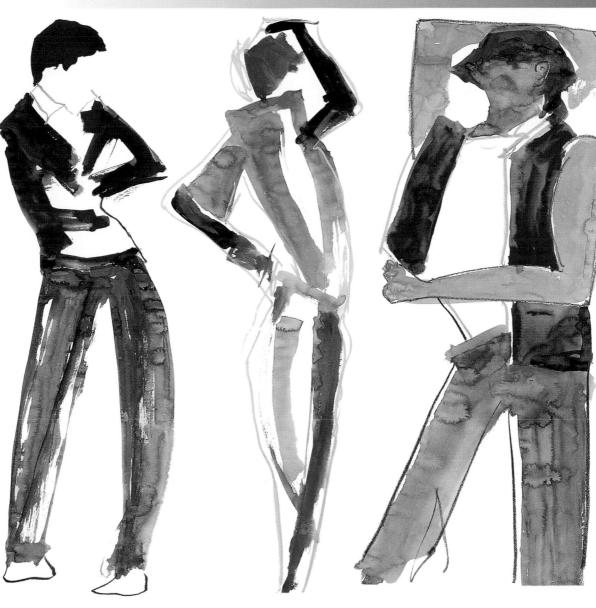

four colors. Apply the color with a broad brush, jotting down the poses with quick brushstrokes. Now you can start mixing your media. Perhaps begin by representing the clothes in paint but use crayon or oil pastel to delineate the facial features.

Remember to try to make each drawing fill the whole page and exaggerate the poses to bring drama to the illustrations. Sometimes it can be productive to ask the model to adopt unusual poses, either seated, standing, or draped over a prop (which you may wish either to include or leave out in order to make use of the white space left on the page). However, be sure that the pose does not interfere with the communication of your ideas.

SEE ALSO

- An exercise in figure drawing, p. 52
- Learn to love your roughs, p. 84

unit 9: showcase

One of the most stimulating aspects of working with a life model is having to use every second of the session to best advantage. The challenge of responding quickly to fast-changing poses brought an urgency and spark to these drawings. A bold commitment can make any drawing state its case: these figures were drawn to fill the whole page, with the model's extreme poses exaggerated to bring energy to the picture. Unexpected colors enliven what might have been a dull subject; a cursory glance at a magazine proves that, in fashion images, skin is not always flesh-colored, hair not always natural. The confident use of different media, such as gouache and oil pastel, can also lend vibrancy to a posed subject. It is important not to be afraid to make mistakes. Done quickly, some drawings will inevitably not be successful, but the ones that are will retain a freshness that is destroyed by overworking an idea.

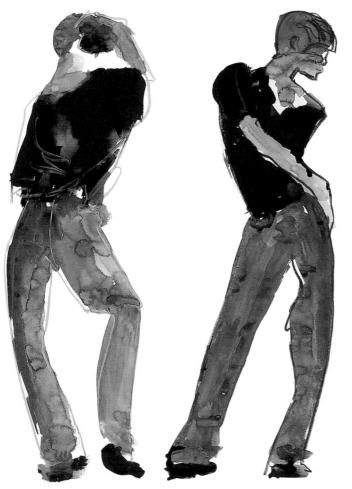

Exploiting color and medium

These illustrations use both color and medium to good effect. The purple hair and greenish skin harmonize well with the tones used for the clothes. The limited color palette has ensured an uncluttered representation of the garments. Using only pencil and paint applied boldly with a wet brush, the essence of each pose has been swiftly identified and captured on paper.

Less is more

Each page has been filled with an interesting composition that not only gives a graphic representation of the individual garments but also suggests the spirit of the ensemble. Too much attention to detail can undermine communication of the overall design theme.

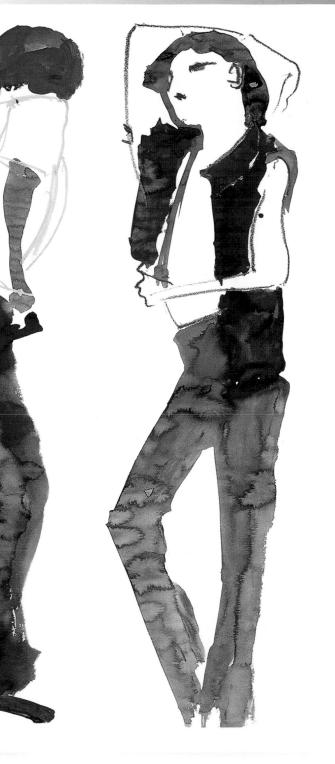

umit 10

Exploring collage

As a designer it is essential that you explore all the drawing and illustration tools available to you. One of the most liberating techniques is collage. There are so many ways to use this medium—you can use bold cutouts of colored paper, tonal newsprint, or colors and textures torn from magazines.

An unusual way of working with collage is to take the technique into the life class. Either by freehand ripping or more detailed cutting you can represent an illustration without drawing at all. Just as with the lifedrawing sessions, working quickly adds spontaneity to the result. You are forced to make instant decisions to get the idea down on paper before the pose changes. This can be testing when you have to find both the source material and then cut and apply it. Don't go for the obvious choices; you can create an interesting illustration by using unexpected blocks or strips of found images (as shown opposite).

Collage frees you from the need to use drawing skills while at the same time increasing your visual vocabulary. Using other means of realizing the model's poses will open up your drawing to new approaches. Collage-making may seem like the type of thing you did in grade school, but that is not surprising, because you were not encumbered in those early days by preconceived ideas. As a designer you will need to banish the baggage of ordinary expectation.

Creative collage

You can cut up magazines, wallpaper or fabric samples, greeting cards, posters, packaging, and a host of other items.

the project

Access a pile of old magazines on any subject. Make sure they contain lots of photographs to use for your own creative purposes. Either enlist a friend to spend a day as your model, or attend a life class. Make up to five representations of your live model, using material taken from the magazines. Naturally these will take a little longer than drawn poses, but set yourself a challenging time limit for each representation.

the objective

 Explore a new way of getting your ideas down on paper by using cuttings as your medium, rather than more conventional tools such as pencil and paint.

 Free yourself from preconceived ideas of how an image can be used so that your work will be original and have spontaneity.

SELF-CRITIQUE

- Have you filled the page well?
- Did you use material from magazines in an inventive and unexpected manner?
- Does the result reflect freshness stimulated by the speed of execution?
- Did you resist using a pencil?

as possible, though you may not wish to include props such as chairs. Use scissors or a craft knife, or just rip the paper to get your cuttings ready to apply; then paste them to the page. Try not to spend too long on any individual illustration; instead keep your work fresh by setting a time limit for completing each piece. Accentuate the figure on the page to create a dramatic effect. Don't be tempted to enhance the pictures with your own freehand drawing and painting. During this unit you should be focused on learning to use the magazine images to best effect.

the process

Bring a good-sized stack of magazines to the session. Ask your model to fall into an interesting pose—and the more uncomfortable the pose, the less time you will have to select, cut, rip, and paste paper onto the page!

Think laterally as you work with your material, combining unlikely colors and textures. Always try to fill as much of the page

SEE ALSO

- Drawing from life, p. 58
- Not just pencil, p. 70
 Laying out your page, p. 74

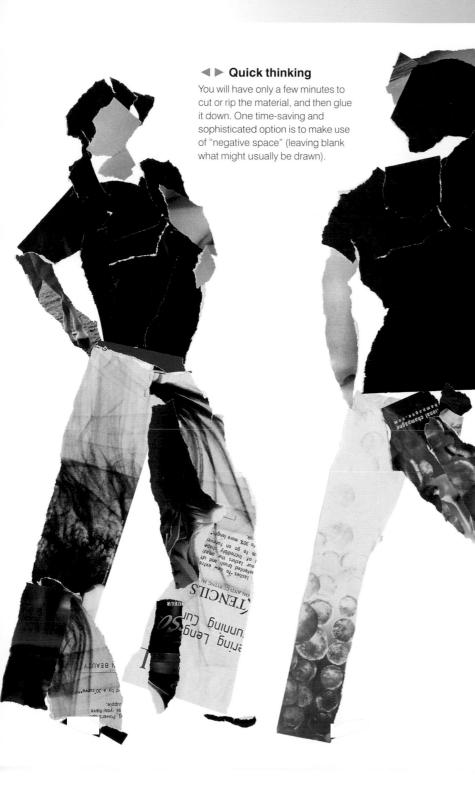

HINQUA

unit 10: showcase

Exploring different ways to illustrate garments can be liberating for a designer. Although putting pen or paint to paper is the obvious approach, the use of collage can produce particularly intriguing, contemporary results. Collage is in fact often used in final design illustrations, but working with it in the spontaneous environment of a life class is an especially interesting and challenging technique. The need to select, cut, and paste very quickly in response to fast-changing poses added freshness and a sense of immediacy to these illustrations. They fill the page and make a statement: the bigger the image on the page the stronger the effect will be. A bold tearing approach worked well in conjunction with more carefully cut outlines. (If the result looks a little rough at the edges, the presentation can always be improved later by feeding it through a color photocopier.) Working with collage, the designer is continually challenged to think one step ahead. The results, however, are wonderfully unpredictable.

New approaches

This collage enlivens the subject with its juxtaposition of unexpected colors and patterns. Creating a collage encourages the designer to think more deeply about the color palette, fabrics, and overall style of the garments.

SP. CIAL OF

The restricted color palette of these collage illustrations creates a fresh, modern effect. The scraps of paper were selected from magazines for their interesting textures and coordinating tones, and then torn out or cut with a craft knife.

FAB28R

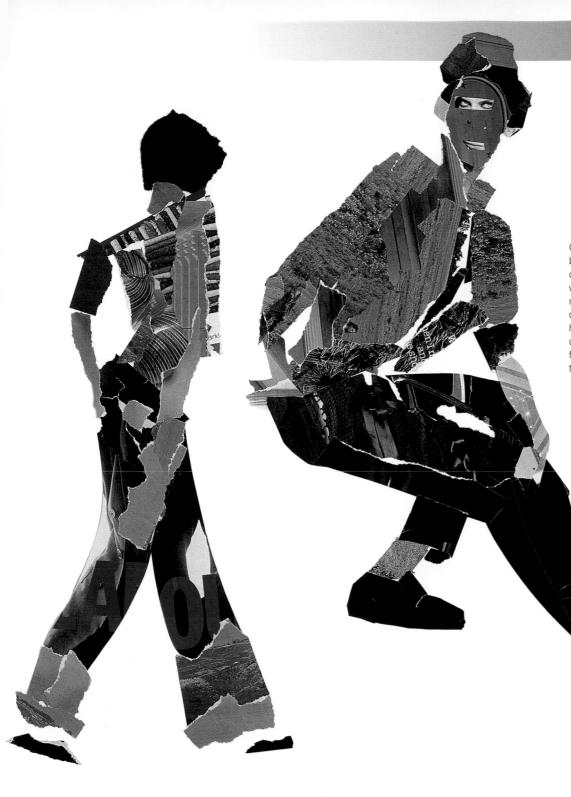

Creating an illusion

Cuttings from different sources can be collaged together to create the overall effect of a human figure wearing garments. It is not necessary to represent every part of a figure to make it believable: here, "negative" (white) space, used at the ankles of the girl, for example, lends vitality to the illustrations.

យ៣រំំំំំំំំ វៅ

Drawing from your wardrobe

t is never easy to put that first mark on a blank sheet of paper. A valuable exercise, therefore, for the student of fashion design is to practice drawing a collection made up from garments that already exist, giving an overall look to a selection of unrelated items. By choosing pieces from your own wardrobe, you are making sure that you start with clothes that you like and already coordinate to best effect every time you go out. You know on which occasions you would wear them and therefore have some idea of the style of illustration that might be appropriate—casual, chic, or glamorous. Sometimes you need to be very literal in your drawings; at other times you can be more flamboyant. In this unit, you will explore how to project not simply the shape and color of the clothes but also the overall image. Boldness is often the best approach-be confident and use your own style in your illustrations.

the project

Select four combinations of garments from your wardrobe that could be loosely described as a collection and combine them in different ways. Experiment with various styles of drawing. Find a common theme to make the selection look like a coordinated collection. Complete four illustrations of the outfits.

the objective

- Take a more detailed look at clothes with which you thought you were familiar.
- Focus your mind on different styling possibilities and color combinations.
- Think of the best ways of representing the fabrics and overall image of the clothes you are portraying.

🖤 🕨 Planning a range

This selection of tailored jackets, trousers, and a skirt seemed likely to work well together as a collection. Photograph the pieces you select, cut out the photographs, and then make some pencil sketches pairing items together.

the process

Hang up the garments or lay them out on the floor. Take photographs and doodle some figures on sketch paper to come up with ideas for poses. Try out paints and crayons to create a color palette that, with some artistic license, represents the actual color of the garments.

Next, try to give the collection an overall look. This can be achieved by applying common themes to the series of illustrations. For example, you could draw the figures in similar poses, or represent them all in a minimalist style, or make use throughout of areas of white "negative space" that omit an outline.

You want your work to look fresh so don't be too uptight about the finished drawings—be bold. Work quickly and just keep going if the first attempts are unsuccessful.

SEE ALSO

- Not just pencil, p. 70
- Illustrating bold print, p. 76
- Planning a range, p. 88

Capturing the colors

Having tested a few color swatches, use crayons and paints to practice making representations of the fabrics used in your selection of garments.

Remember the details

These marks were made to test different ways of representing the hair of the posed figures.

SELF-CRITIQUE

- Have you chosen the best clothes for the collection?
- Did you coordinate them well?
- Did you find the best medium to represent them?
- Have you used simple but effective poses?
- Does your collection have an overall look?

unit 11: showcase

Ilustrating found garments, rather than original ideas, is a very useful way for a designer to develop observational skills. By looking closely at clothes that seemed familiar, it is possible to spot previously unnoticed aspects of construction or embellishment. Whether it is the cut of a neckline or the detail of a fastening, this new observation can be of use in a designer's work.

It is important to select carefully the garments to be illustrated, considering which elements will form the main strengths of the planned collection. This task introduces the process of planning a range (see page 88). As can be seen from the examples here, the garments may be fairly ordinary individual pieces but, when put together in a stylized way, they form a collection with a powerful overall image. Once the poses have been worked out and the colorways mixed, the designer needs to decide on the most striking way to get the images down on paper. This is where it is important to choose a strong style and cohesive theme that will hold the garments together as a collection.

Consistent stylization

These sketched figures explore stylized aspects, such as horizontally extended hair and an outstretched arm, that will be applied to the whole series of illustrations.

Minimalist theme

These minimalist representations focus attention on the silhouette and color palette. This consistent approach, along with the other uniformly applied stylization details, ensures that a group of unrelated garments is given the feel of a planned collection.

Extended hair is an unusual theme common to all the figures.

Reading between the lines

These images make bold use of "negative space," leaving some white areas untouched so that the invisible lines can be read. The pictures are clear without being obvious and are more interesting as a result.

A sense of unity

Repeating poses, such as placing the figures with hand on hip or left arm extended, gives the series of drawings a sense of unity. G

umit 12

Not just pencil

When one uses the term "drawing," the most obvious tool that springs to mind is a pencil, with all its various grades from hard to an almost creamy softness. However, as you have seen in Unit 10, you can "draw" even with paper torn from a magazine. When you use your imagination, there is no limit to the materials you can employ to achieve the look you want. Slow-drying paints, such as oils, are not really suitable for use in fashion illustration, but there

is a wide range of other media to choose from, including colored felt pens, waterbased paints, crayons, or a mixture of several of these. In recent years, the mouse on a personal computer has

> to some designers become equal in importance to the pencil and brush. Some materials may suit your way of working better than others, but until you have tried a large selection, you will never know. Experimenting with new ways of working is very stimulating and also enjoyable. It is worth repeating that it is never a crime to try and fail. It is understandable to want to have pride in your work, but you will produce only mediocre ideas if you always play it safe.

the project

Using some of the more easily available materials, such as gouache paint and oil pastels (water-based acrylics and crayons do not work for this project), select a restricted range of colors: perhaps three pastels and three paints. Design a collection of four costumes with a theme and distinct color look. Ensure the final drawings make a bold statement about your concept.

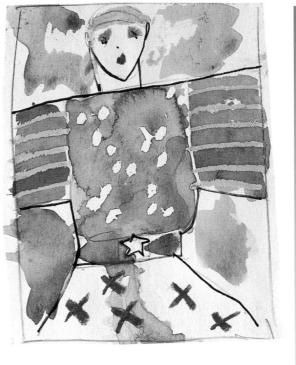

the objective

 Experiment with using mixed media to open up new approaches to a design.

 Explore the idea that a collection of drawings will make a better presentation if a theme is strongly and consistently illustrated.

 Create a cohesive look by applying colors simultaneously to all illustrations instead of completing one picture at a time.

SELF-CRITIQUE

- Did you choose colors that work well together?
- Were your final illustrations bold?
- Did they have a cohesive look portraying the essence of your designs?
- Was full use made of your different materials?

the process

From the vast range of inspiration toward which vou were directed earlier in this book, select a theme on which to base your collection. Try out your chosen colors together to make sure they are a good combination. Next. quickly test some ideas by first drawing with oil pastels, then washing over the marks with watery but full-colored paint. The oil pastel will resist the paint and create interesting contrasts.

Then lay out four sheets of paper (20 x 30 in.) in front of you. Using pencil, and covering as much of the page as possible, confidently draw the outlines of your designs.

Now methodically apply the oil pastels, color by color to all the drawings simultaneously. Keep your nerve! Finally, use the paint, applying one color at a time to all the illustrations.

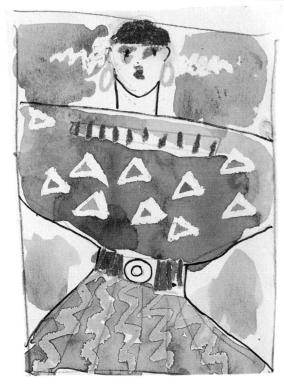

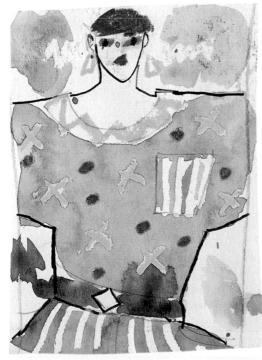

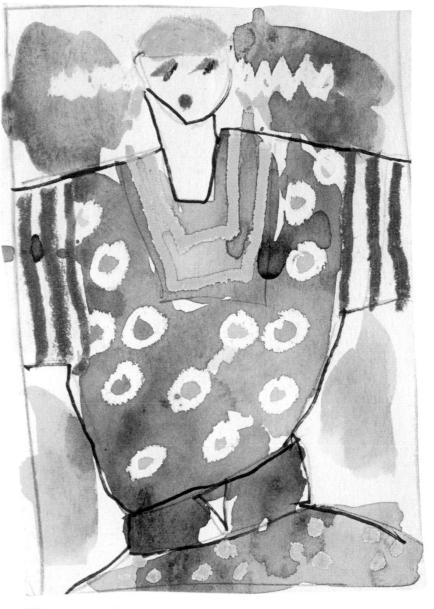

Mixing your media

The colors and themes of these roughs were adjusted for the final designs (see pages 72–73), but the technique used was the same. Here, yellow oil pastel was applied to all four drawings, followed by white, and then pink. Then paint was added, one color at a time.

SEE ALSO

- Illustrating bold print, p. 76
- Learn to love your
- roughs, p. 84
- Planning a range, p. 88

unit 12: showcase

Experimenting with applying and mixing different media can achieve stunning results. Unusual combinations of techniques lend a freshness and originality to fashion illustrations that really makes them stand out from the crowd. As seen in the designs pictured here, a striking effect can be achieved by using oil pastel as a starting point and then adding a watercolor wash over the pastels, exploiting the crayons' properties of resistance. By choosing the color palette before the design is committed to paper, and then applying the colors step-by-step onto the whole series of designs at once, a designer can ensure that the common concept comes through strongly over a whole series of illustrations. Working in this way, all the pictures will come to completion at the same time and a powerful overall look will emerge.

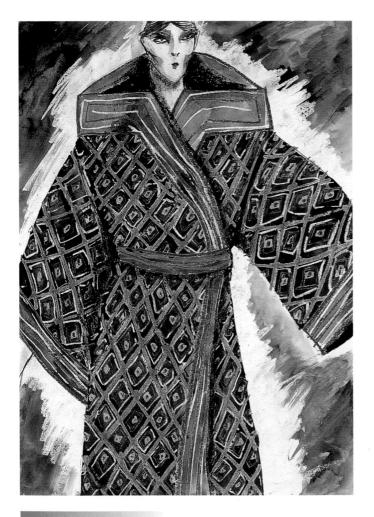

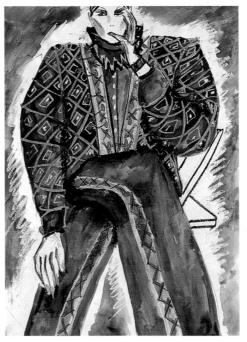

Vibrant colors

In these final illustrations, the initial color ideas have been rejected for a more subtle mix of understated tones. The resistant qualities of the oil pastels have been used to create a paint-free aura around each figure, highlighting the wash of the water paint and making even muted, subtle colors look vibrant.

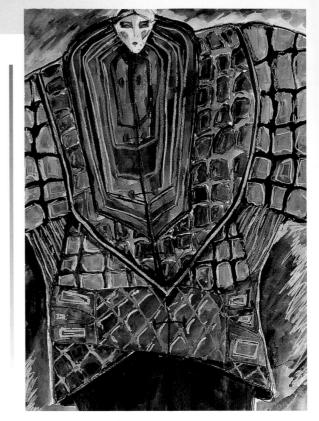

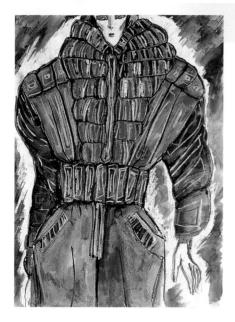

◄ ▼ ▲ Unifying features

The group of drawings has been given cohesion through the use of well-delineated figures, each with an aura, as well as through the consistency of the colorway and the uniform medium-level application of the media.

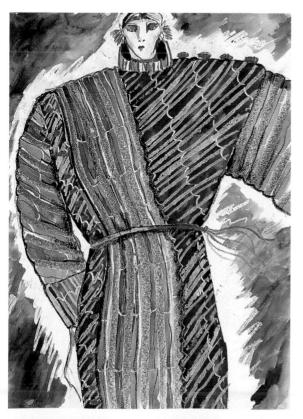

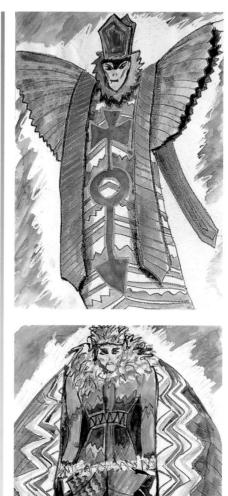

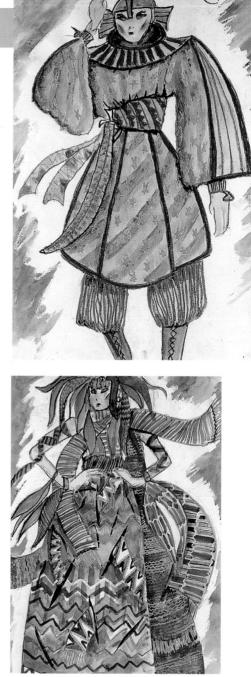

▲ Fantasy theme

The four illustrations pictured above form a strong collection unified by the theme of the fairy tale. Each page is filled with design ideas that express the costume feel of the collection.

inspiration file

Laying out your page

A designer is in the business of visual communication, whether the information is presented purely pictorially or with the addition of words. The pages of this book have been designed to impart the information of text and illustration with maximum clarity and visual impact. That is what you should aspire to in any work that is to sell your ideas successfully to the client.

When students start out illustrating designs, they tend to be a little tentative about attacking the daunting blank page in front of them. The result can often be a small, faint drawing in the corner of the page or, only marginally better, in the center surrounded by vast areas of white paper.

It is important that your drawings reflect the spirit of the subject. If, for example, you are illustrating something inherently bold, such as a Hawaiian beach shirt collection, the drawings must be equally bold. It is always worth making

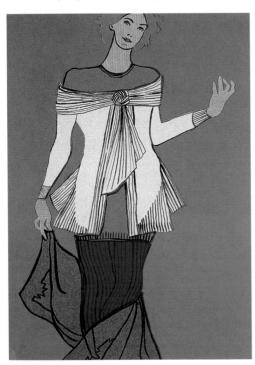

rough sketches to plan your page and ensure that the information you are trying to portray is foremost. For example, drawing an elongated figure with long legs when the point of interest is a shirt wastes valuable page space to tell your real story—the wild print of the shirt.

It is worthwhile remembering that you don't want your page to be cluttered. Most of the area should be filled but not with too much information; the phrase "less is more" is very often appropriate here. It is the main message that you are trying to put across; remember the minimalist examples in Unit 11, Drawing from your wardrobe.

It can sometimes help to prepare the page with a color wash or areas of colored paper to give a texture from which to work up your image. Another technique to ensure you fill the page is to think outside its edges. You can do this by laying the sheet of paper you are

Don't cramp your style

Fill your page boldly by laying it over a larger sheet and drawing over the edges, or by starting with a very large page and cropping it later so as to achieve the best composition.

Avoid clutter

Use your sketchbook to experiment with filling a page. You should try to make a strong statement about whatever you are drawing, avoiding unnecessary clutter.

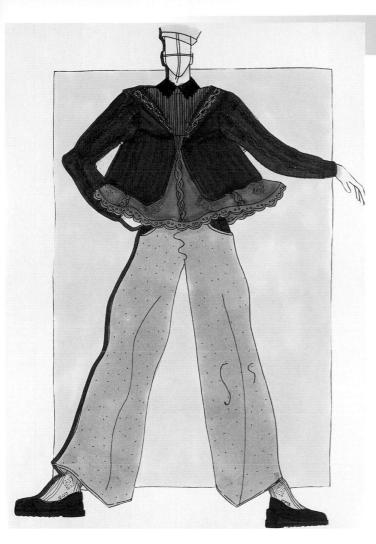

working with onto a larger sheet and then drawing over the edges. This will allow you to avoid the trap of cramping your style as you approach the edge of the page. The same effect can be achieved by starting on a sheet of paper larger than you intend to display, completing your illustration, and then cropping it bravely to produce the best composition.

When planning a page it is usually best to start at the top and roughly plot where you want the head (or even just half the head) to be, then work down the figure. You must also be constantly aware of the side margins. The magic word to strive for in page layout is "balance." That doesn't mean uniform

■ Balanced stance This feet-apart pose fills the page in a satisfying way, the extended left hand echoing the position of the right foot.

symmetry, just an innate feel that the picture is well composed and at the same time tells the main story of the garment.

In fashion illustration you will mainly be working in "portrait" format, in which the sheet is positioned with its longer edges at the sides and shorter edges at the top and bottom (as opposed to "landscape" format, in which the longer edges are at the top and bottom). However, this is not a hard and fast rule. As you see, this book is in a square format, which produces a landscape spread across two pages.

Trial run

It is a good idea to experiment with different page layouts before committing yourself to the final design.

Double vision

Using more than one figure in the same illustration can strengthen the impact of the garment—but be careful not to lose your focus.

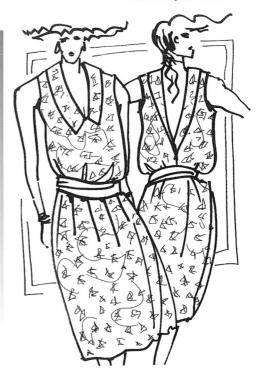

umit 13

Illustrating bold print

t is just as skillful to be able to illustrate the work of other designers as to portray your own. This is the job of the fashion artist as opposed to the designeralthough fashion illustrators will, of course, bring their own design skills to the interpretation of the garments they have been commissioned to depict. As a fashion designer, however, it is also essential for you to be able to communicate your ideas effectively on paper. In order to do this you need to have the skills and objectivity of an illustrator at your fingertips. A good designer is a good illustrator. In this unit you will look at illustrating the print designs of found garments to practice the process of observing clothes closely and capturing their story on paper. By doing this, you will learn how to use the page to best effect to make as strong a statement as possible about your own design ideas.

For this exercise, it is best to illustrate a simple but striking subject, such as a Hawaiian beach shirt. These garments are timeless, and there will be many examples available for you to choose from.

the project

Research images of Hawaiian beach shirts and complete at least four bold illustrations using any medium you think appropriate. This theme could especially suit oil pastel and gouache, or perhaps bright inks with pen and brush.

the objective

Observe closely the garments to be drawn.

- Work out a shorthand way of depicting the print.
- Find a suitable pose that fills the page and makes a strong statement about the shirt.

▲ ► The most unlikely sources Visit a charity store or delve into your friends' wardrobes to see how many sensational prints you can unearth.

▲ Surfer's paradise Here is a possible selection of shirts to work with. The brighter the better for this exercise!

the process

Research striking beach shirts by taking photographs of displays in stores or cutting images from magazines and catalogs. You will have the color and design references on hand, so

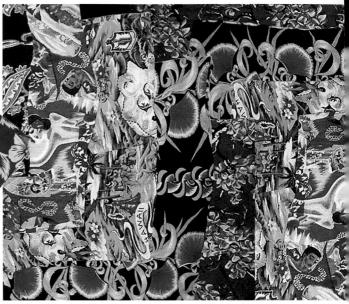

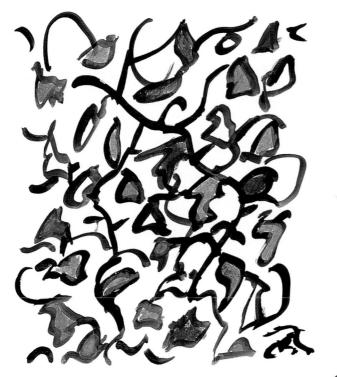

you are featuring. Draw preliminary outlines in light pencil; then start working in the colors, marking the head and features of the shirt such as the sleeves and collar. Complete your four drawings by adding details such as hair and a background, if desired.

▲ ► Mix and match

Explore ways of matching colors and motifs. If using paints, mix them to achieve the bright colors of the clothes. Your shorthand for conveying the motifs could be literal or impressionistic, as demonstrated in the examples here (which are try-out illustrations of the shirt prints pictured opposite).

SELF-CRITIQUE

- Could you really go to town in illustrating your selection of shirts?
- How well have you matched the colors?
- Do your motifs look like the originals?
- Is the scale correct?
- Did you choose a suitable medium?

SEE ALSO

- Drawing from your
- wardrobe, p. 66
- Not just pencil, p. 70
- Color palettes, p. 104

unit 13: showcase

Boldness is always the best policy in realizing a design drawing. Subtle designs are more difficult to render because the minor nuances can easily be lost. An uncompromising "between the eyes" statement produces the most striking results, whether it involves a strong silhouette or vibrant colors, or a combination of both. The bright patterns of the Hawaiian beach shirts illustrated here provided a great starting point for demonstrating how to represent motifs vibrantly and make best use of the whole page. The salient aspects of the garments were identified and captured on paper. Because the prints are the focal point of the designs, there was no need to get too involved in detail relating to the shape of the garments. The completed illustrations are not reliant on colorways or silhouettes to hold the look together but on the consistent and strong page-filling realization of the shirts.

Powerful design

Although the range of colors used in this design is fairly broad, the strong shapes of the pattern ensure that the representation is not cluttered. The overall effect of the image is very bold.

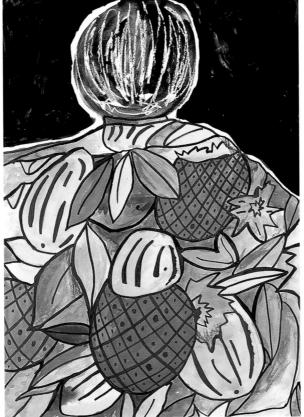

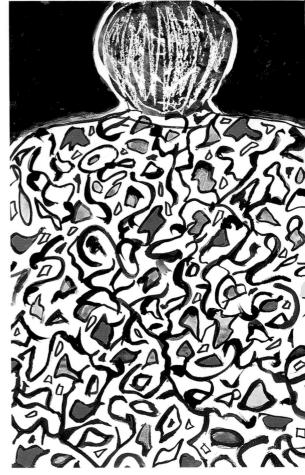

An alternative view

Because the focal point of the designs is the print and not the garment, the innovative decision was made to draw from the back, a point of view often neglected when illustrating fashion design.

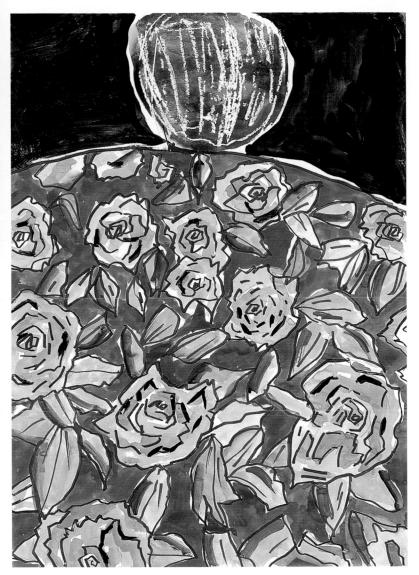

▲ Using a fuller figure

Another interesting innovation made was to model the shirts on a fuller figure. This is the body shape that will best show off the garment's most interesting feature—the print.

V Original tools

The prints have been carefully observed and their colors and motifs faithfully replicated in oil pastel, felt-tip pen, and water-based poster paint—which may well have been the tools used by the original print designers.

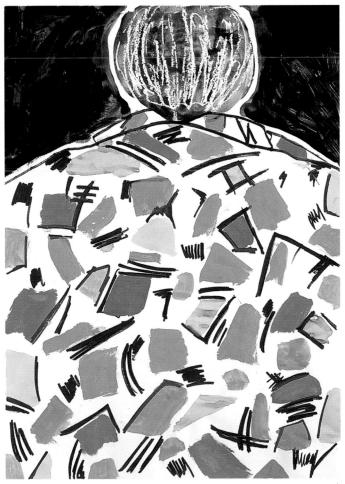

chapter 3

PLANNING AND DESIGNING

As a designer you cannot afford to be self-indulgent, but should instead try to produce work that is commercially viable. This chapter explains how to develop a cohesive collection and plan your range to offer as much choice as possible. You will also learn how to target your designs toward a customer profile and specific end use, and to work within the constraints of the season and budget. The chapter also examines how to apply a color palette effectively throughout a collection and to structure fabric to create the silhouettes you want.

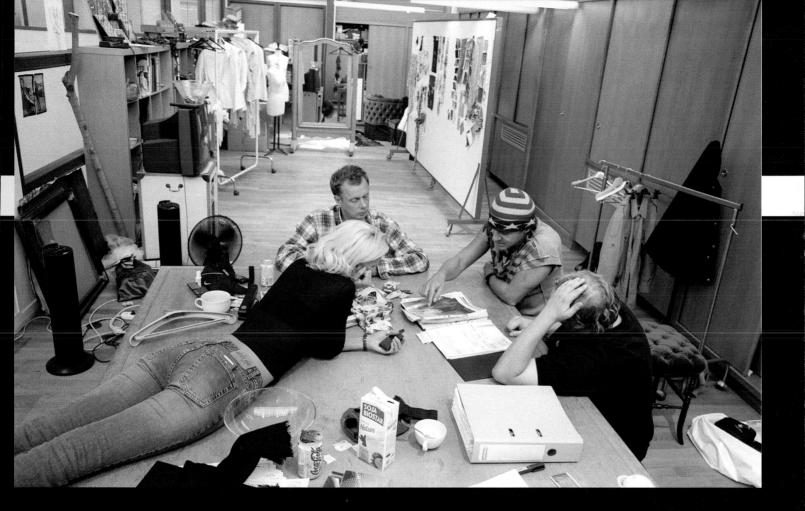

▲ To be successful in the commercial world, designers such as John Galliano have to plan collections that offer customers both excitement and choice.

inspiration file

Creating a cohesive collection

Fashion designers develop a whole range of related ideas to produce groups of garments that work not only as stand-alone outfits but also as a collection. A consistent approach to important factors such as color, shape, pattern, and proportion helps to create this cohesion.

It is this systematic development of ideas that enables the designer to think laterally and to get the most out of each concept. With practice and experience, you will learn not to settle for the first idea that comes along but to push yourself to generate a series of related concepts. You may be surprised at the results as you progress away from your starting point and down new avenues of creativity. The collections that you develop will have a natural cohesion because they contain similar and related themes, and you will soon find yourself creating a coordinating range of garments rather than separate and unrelated outfits.

An important factor in this process is to learn to be comfortable with thinking out loud on paper. This means feeling relaxed about noting down your ideas and sketching out series of designs. You must learn to love your roughs! A blank page can be intimidating, and it is easy for the novice designer to become so concerned with the appearance of the initial sketches that the actual design process takes second place. With practice you will gain confidence and be more relaxed about encouraging the flow of ideas. Remember that you are just developing your thoughts, not trying to create a masterpiece. It does not matter how well executed these roughs are; they are for your purposes only and do not need to be judged by anyone else. All that matters is that the roughs assist you in working through your stream of ideas. Using the more casual medium of a scrapbook may help you relax about your rough work, and you will be able to combine drawn ideas with

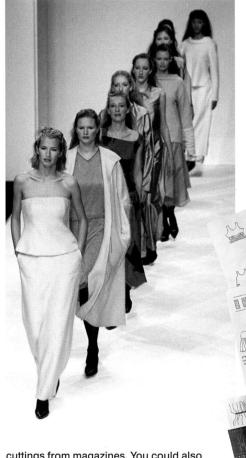

cuttings from magazines. You could also try keeping a notebook with you at all times so that you can jot down ideas as they come. With time you will discover which methods work best for you.

Mix and match

This collection by Betty Jackson comprises a selection of different garments, including eveningwear, daywear, and outerwear, and demonstrates how designers need to plan coordinating ranges with a unifying overall look.

Drawing on the ideas bank

Store garment-detailing ideas in your sketchbook and select themes to apply to a group of garments in order to achieve a naturally cohesive collection.

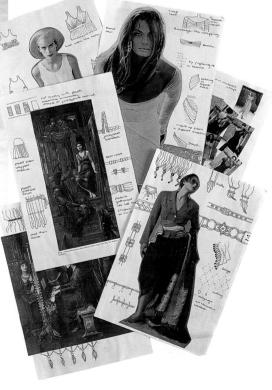

Working with "flats"

Working with flat garment outlines may help you develop related ideas and build up a unified collection.

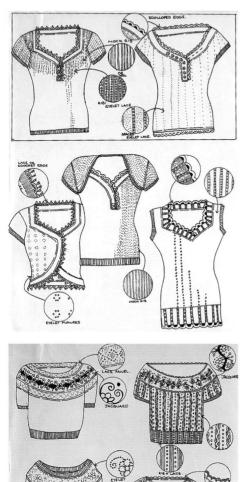

Distinguishing details

Decorative details can be used to unify a range; alternatively (as here) different details can add variety to a range that shares a common outline theme.

This page of sketches is an example of planning on paper. Don't worry if your initial

umit 14

Learn to love your roughs

t's time to start thinking like a designer! The more you can relax and not worry about how someone else might respond to your drawings, the better they will be. Remember that you are not yet producing final illustrations or even communicating your ideas to anyone else. You are simply thinking out loud on paper. If you feel daunted by the blank page, try beginning by jotting down a list of words as ideas come into your head. You might include descriptions such as "rounded," "sophisticated," "feminine," or "soft" to evoke your target customer and the kinds of garments that you might design for her or him. This will make starting to sketch much less intimidating. Your rough sketches may be drawn on a figure or as flat garments with carefully considered proportions.

the project

Choose your theme and produce some first rough garment ideas, considering in particular what it is that inspires you about your research. Select the strongest ideas and expand on these, using a layout pad. Trace over your initial visual thoughts to produce a series of designs, changing one element with each new drawing. The result will be a series of variations on a theme.

the objective

- Create a set of ideas that holds together as a collection.
 Use roughs to expand on your starting point.
- Avoid the obvious and develop your own unique style.
 Assess your ideas as you work and develop the strongest designs.

SEE ALSO

- Planning a range, p. 88
- Customer focus, p. 94
- Working drawings,
 - p. 116

A variety of shapes

Initially, you could explore a number of garment shapes using "flats." Remember that you are aiming to produce a collection of outfits comprising related but varied garment types.

the process

Think carefully about your starting point, considering its colors, textures, shapes, patterns, and symbolism. Jot down some ideas on paper, using words as well as quick sketches. Taking the stronger ideas further, produce some rough designs on a layout pad. The thinner paper of the layout pad will allow designs to be easily traced one on top of the other, but take care not to work into the paper too heavily, as it can bleed color through to the sketch below. Work by tearing out one drawing and laying it beneath a clean page to make the next, adapting the previous design. Push yourself to produce lots of ideas, changing one element with each new drawing and building up step-by-step a series of related garments. Now you are truly thinking like a designer, as you create a cohesive collection.

Aim to produce about twenty rough outfit ideas. As you work, keep in mind the inspiring features of the starting point. Assess all the rough drawings by placing them next to each other (you can photocopy your sketchbook pages

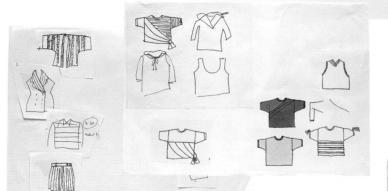

Working on

Translating your "flats"

about proportion and

garment layering

onto figure sketches will

help you think more clearly

the figure

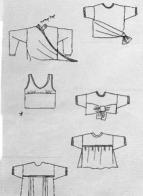

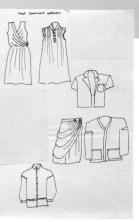

Layering sketches

Work with a layout pad, drawing garments either on the figure or, as shown here, as flat sketches. Tracing ideas one on top of the other encourages a progression of ideas while ensuring that garment outlines remain related.

Considering all the angles

Remember to work through ideas for back views as well as thinking about the front of your designs.

and line them up, if necessary). Select the five strongest ideas for your portfolio—those that best capture your inspiration and hold together as a collection. These drawings can then be perfected to create finished illustrations.

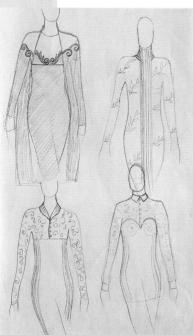

SELF-CRITIQUE

- Were you confident enough to note down your ideas in an unself-conscious way?
- Did you expand from your starting point to create unique designs rather than simply drawing the obvious?
- Have you chosen the strongest ideas from your roughs?
- Do your five chosen roughs look as if they belong together in a collection?

leas in an

unit 14: showcase

The creation of roughs is an important part of the design process, especially if the designer is trying to give the collection a strong overall look. Roughs are used to get all the related ideas about a source down on paper. Only once this has been done is it possible to assess all the sketches objectively and decide which work best as a collection and should therefore be taken to the next stage. As shown here, the successful roughs are those that work as individual pieces but also sit well with the other ideas because they have certain design themes in common.

The designs pictured here are clearly related to one another in both the details and the sihouette, yet are each interesting and unique garments in themselves. Refining ideas beyond the rough stage ensures that designs progress beyond the obvious and prevents the collection from being derivative or repetitious.

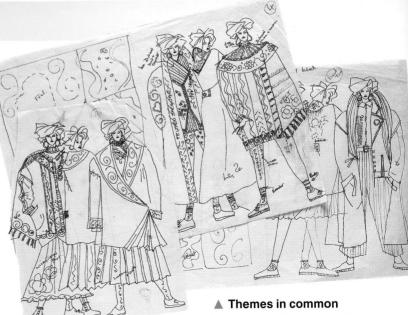

In these roughs, the garments already have the feel of a cohesive collection, unified by an Asian look and design themes such as the fringing and embellished details.

The creative basis

As ever, the successful development of ideas was supported by the compilation of a strong color palette and mood board, in this case featuring an Asian theme.

First thoughts Image Address First thoughts Image Address First though the second seco

This rough was used to establish silhouette and proportion; the decorative detail was added later in the process.

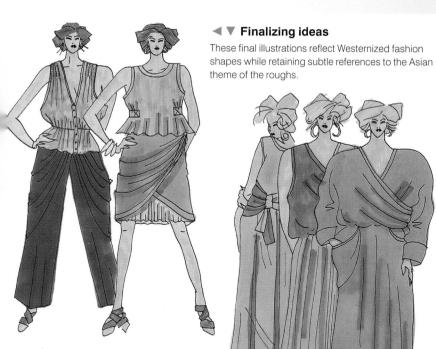

Offering variety

An idea such as draping soft fabric can be applied in many different ways to similar garment shapes.

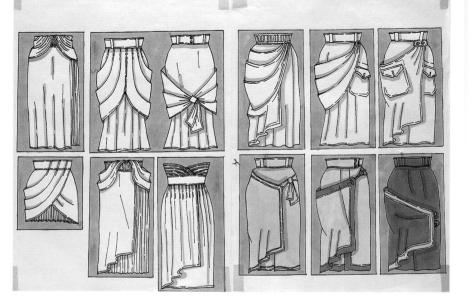

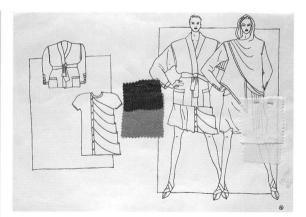

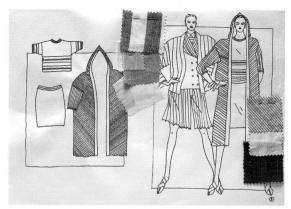

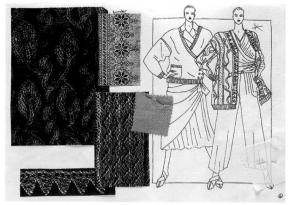

▲ Pattern, color, and silhouette These illustrations have been given a unified feel by the pattern and color of the fabric and by the flared silhouettes of the designs.

unit 15

Planning a range

The words "range" and "collection" are often used interchangeably in the fashion industry to denote the group of garments created each season by a designer. However, "range" also has more specifically commercial overtones. Range planning involves considering your designs in terms of a complete wardrobe of coordinating garments, incorporating a balance of tops, bottoms, dresses, outerwear, and so on. When you see garments by your favorite designer displayed in a boutique, you are experiencing range planning. The newness and trendiness of the garments are obviously important, but the boutique also needs to appeal to its customers with a variety of options of garment type that coordinate and are interchangeable.

Sometimes a client will brief a designer to create a specific range. This might be a swimwear, bridal, or eveningwear collection, for example, and the choice of items to include in the range will be very much dictated by the brief. If you have been asked to design an eveningwear range you will probably want to include a large number of dresses—as in collections of eveningwear by Versace. It is perfectly acceptable to bias your range to one garment type in this way so long as the decision is based on the client's brief.

the project

First brainstorm ideas about a daywear range, without worrying too much about the appearance of your sketches. Then map out garments that you think might be suitable for inclusion in the range and consider how they can be worn together as outfits. Finally, illustrate the best combinations as finished drawings of eight outfits.

the objective

- Select designs that hang together as a collection.
 Offer a good choice of individual pieces within
 - the collection.
- Create a range of garments that look good in their own right but can be easily mixed and matched to make different outfits.

Choices

When visiting your favorite boutique, observe how the choice of garments available has been planned as a range of mix-andmatch outfits.

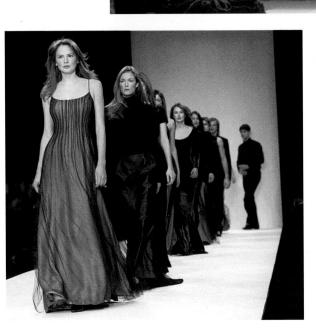

SELF-CRITIQUE

- Have you created a cohesive collection of garments?
- Do all the pieces work well together throughout the range (and not just as part of the outfits that you have illustrated)?
- Would a customer of a boutique selling your designs have a good choice of garment types?

A planned range

Every collection is a planned range of outfits. Here Jasper Conran is showing a range of eveningwear pieces that coordinate as a collection because of their common colors, shapes, fabric treatments, and silhouettes.

the process

You should be gaining confidence in your rough sketches as you work through the projects in this book. Again, just rough out the ideas as they come to you and do not worry too much about what the sketches look like-you do not have to show them to anybody else. There is no strict plan at this stage, simply an outpouring of thought about garments that might constitute a daywear range.

Reconsider your raw ideas, as you have done in previous projects, this time exploring how they

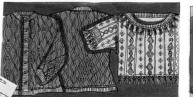

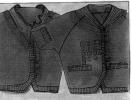

▲ ▼ Considering the details

Think carefully about the construction and finishing of each piece to ensure that you offer maximum choice within your range.

You may want to plan your range with a series of rough sketches that list the components of each outfit. You can then crossreference each set of garments to ensure that you have included every option of garment shape that is required for your range.

could work together as a range. Try to include a good selection of separates such as short and long skirts, trousers, dresses, tops, outerwear, and so on. The garments should coordinate and be interchangeable so that they can work both as a range and as individual pieces. As you plan, use quick sketches as an aide-mémoire or even draw up a grid in your notebook and list possible combinations of garments. Then, bearing in mind the points above,

select the designs that you want to include in your range. Finally, draw finished illustrations of eight outfits.

SEE ALSO

- Creating a cohesive collection, p. 82
- Learn to love your roughs, p. 84
- Occasions, seasons, budgets, p. 98

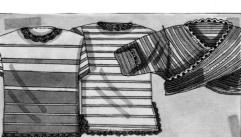

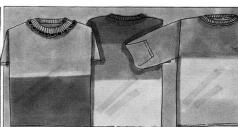

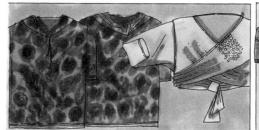

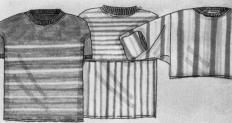

unit 15: showcase

Every collection that a designer creates involves a degree of range planning the aim should be to tempt customers into buying as many items as possible. The ranges illustrated here offer a good choice of garments that clearly coordinate while avoiding unnecessary duplication. All the items are highly interchangeable, and the outfits that have been put together would look equally good reformatted into new combinations.

However, planning a range is more complicated than simply thinking of as many different sorts of garment as possible. A fall collection such as the one featured opposite, for example, will require a variety of pieces that can be layered over each other and may feature long sleeves for daywear items. The age group of the target customer will also affect the types of garment that are planned into the range—the trendy workwear separates pictured below, for example, would probably be aimed at a younger age group.

▲ One source, many designs

Developing a range of designs from one source of inspiration gives cohesion to a collection. The historical working man theme investigated here provoked many ideas about functional workwear separates, which were incorporated into the range shown below.

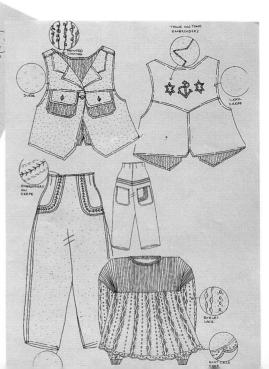

▲ ► Coordination is key

A "working wardrobe" starting point might inspire the inclusion of dungarees or vests within a range. However, it would still be necessary to offer a choice of other pieces to appeal to the target customer and to provide a coordinating range.

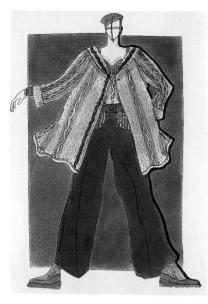

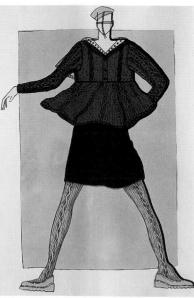

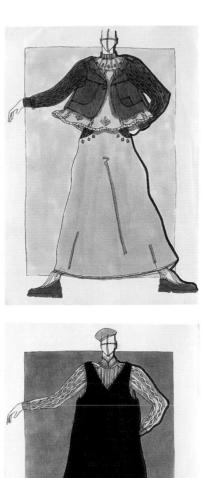

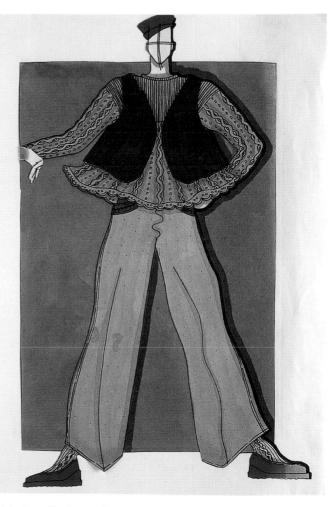

ৰ 🛦 A well-planned range

It should be possible to imagine mixing up all the garments in a range and creating new outfit combinations without any loss of overall effect.

Designing to a brief

As a fashion designer, you will always have a client or target customer in mind. You cannot afford to be self-indulgent and simply create designs to suit your own tastes. It is, however, perfectly acceptable to develop a recognizable style. You will notice that all the famous fashion houses have their own particular style; the clothes have a unique flavor that reflects the philosophy of the designer.

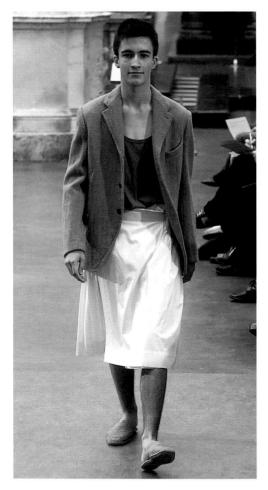

▲ Trend awareness

Skirts for men, such as this example by Dries Van Noten, have been in and out of fashion in recent years. Make sure that your designs are in line with the latest style trend predictions. There are various limitations associated with working to a design brief and it is best to confirm them before you begin. Your budget, for example, will be dictated by the price at which your garments can be sold. It is common in the fashion industry to establish a rigid and logical price structure for all the pieces in a collection—a vest top will be cheaper than a long-sleeved garment, for example—and your designs should reflect this. A garment that is very embellished will have a high perceived value, but you must be certain that the customer is willing to pay the increased price.

You also need to be sure you are designing appropriate garments for the time of year when they will appear and that your work is in line with fashion trend predictions for that season.

Another very important factor is the nature of your target customer. You should aim to construct a profile of the kind of person who is likely to wear the designs you will produce for each project. Fashion designers call this imaginary, or indeed sometimes real, person their "muse." You can create your own muse by building up a selection of magazine images that represent your customer. You will need to consider gender, age, economic status, lifestyle, occupation, and anything else that could influence choice of fashion. What does your muse do for a living? What does he or she like to do on the weekend or in the evening? Where does he or she live? The answers to these questions will help you to build up the profile.

V Lifestyle patterns

What is your customer's social life? This design by Ghost is aimed at someone with sophisticated tastes.

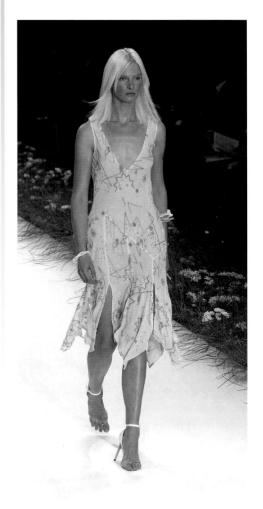

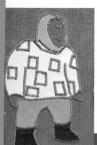

Broad customer appeal

During your career you might be called upon to design for a wide range of potential customers. This may sometimes require you to design garments that do not match your personal tastes.

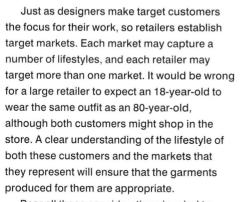

Bear all these considerations in mind to avoid lapsing into designing only what pleases you personally. You need to maintain a delicate balance between your own style and designs that appeal to your customer. As a designer, you may sometimes have to cope with creating garments that you personally dislike. The measure of a true professional is the ability to work with enthusiasm and passion on designs that are focused on someone else's taste.

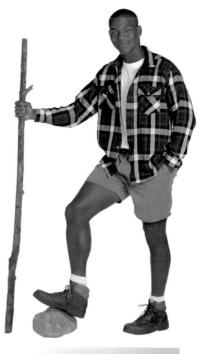

unit 16

Customer focus

s a fashion designer you need to develop the ability to work with enthusiasm and passion on projects that might not appeal to you personally. It is not enough to want to create only the designs that you like. The fashion designer differs from the artist in that there will usually be a customer or client in mind, who will ultimately be paying for the garment. It is the designer's challenge to satisfy the desires of the customer, and there is little room for self-indulgence.

the project

Pick an advertisement from a current fashion magazine that features a person who looks interesting. The advertisement will suggest a lifestyle associated with the person depicted. You have just met vour latest customer! In this unit you will design a collection of eight finished outfits targeted at this person. Challenge yourself by choosing someone very different from the people you have designed for in the past.

the objective

- Learn to research your customer's lifestyle. Target your collection appropriately.
 - Practice the ability to work outside your
 - personal preferences.
- Add a project with a very different flavor to your portfolio.

SELF-CRITIQUE

- Did you truly challenge yourself with your choice of customer?
- Have you been able to work beyond merely designing garments that you like?
- Did you maintain your enthusiasm while working on styles that come less naturally to you?
- Are you satisfied that you have produced an interesting design outcome?

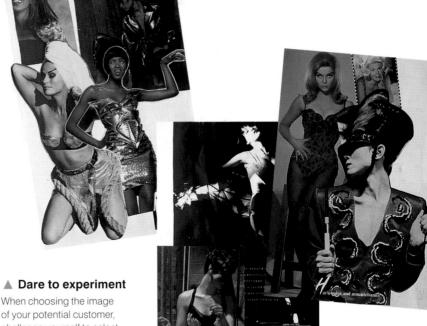

of your potential customer. challenge vourself to select someone who would wear garments that are very different from your previous designs.

the process

Look through some of your fashion magazines and find an image of an interesting person. Try to ao for someone for whom you would not normally consider designing: a person from a different gender or age group, for example. Advertisements are good to work with because they usually suggest a lifestyle associated with the people featured.

Start by jotting down words that describe your chosen customer. How old is he or she? Where

does he or she live, work, and go on vacation? How wealthy is this person? What sort of car does your customer drive, and which newspaper does he or she read? Where is your customer likely to wear the clothes that you are designing? Gradually build up a complete lifestyle profile of your new customer.

Next you can start to plan your range, aiming ultimately to produce eight finished outfits. As you do this, consider your customer's lifestyle, where the clothes will be

worn, and how expensive they are likely to be. Put together a color palette. isolating no more than six to eight colors that you can see within your chosen magazine image. Finally, draw your eight finished outfits, remembering that they are not intended to please you but to appeal to your customer. Endeavor to maintain both enthusiasm and professional pride in your work even though it might not be to your own taste.

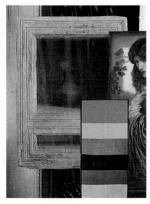

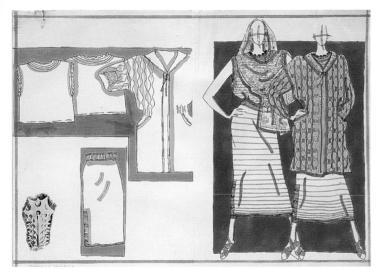

A Presentation

Your presentation should also reflect the customer profile; here, both design and presentation are targeted at a young, extroverted customer.

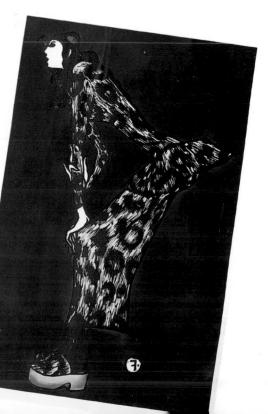

Appropriate ideas

The outlines and fabrics used in these designs are consistently targeted at a customer with more conservative tastes. Keep referring to your lifestyle research: are your ideas truly appropriate to your customer's needs?

SEE ALSO

- Designing to a brief, p. 92
- Occasions, seasons, budgets, p. 98

Matching design to personality

An extroverted customer might inspire you to illustrate in a style that displays exaggerated poses and proportions as well as bold silhouettes and fabrics.

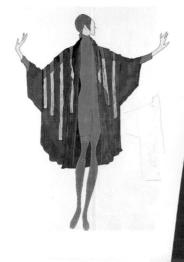

unit 16: showcase

Designers have to strike a delicate balance between appealing to their own tastes and pleasing their customers. Good design and design that appeals to a designer personally are not necessarily the same thing. As the garments illustrated here demonstrate, being a successful fashion designer is not about creating wildly flamboyant costumes that look great on the page but are impossible to wear, but about channeling fashion sense and originality into a customer-targeted outcome.

It is important for a designer to build up a profile of the target customer. This should influence all aspects of the collection, including fabric, color, cost, the formal or casual nature of the garments, and the style of presentation. Clothes are about far more than keeping warm—they are a signal to others of what we feel about ourselves. Understanding the client and the client's aspirations means understanding what messages he or she would like to give out. A successful collection is perfectly constructed to reflect these signals and so to satisfy the customer.

▲ ▼ The process of selection

The strongest of the first ideas were selected to sketch in more detail. These knitwear designs were appropriate to the relaxed daywear needs of the target customer.

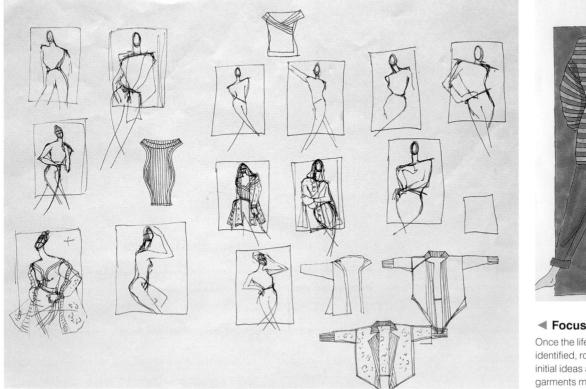

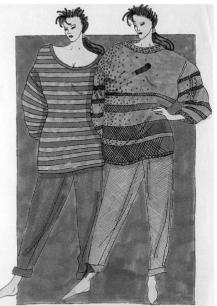

Focused roughs

Once the lifestyle of the chosen customer was identified, rough sketches were used to explore initial ideas about when and where different garments might be worn.

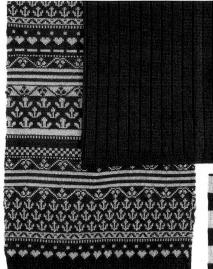

▼ The right fit

The fit of a design is also lifestylerelated. The garment might be figure-hugging or it may have a more comfortable, casual look.

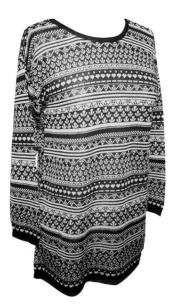

Suitable fabrics

The lifestyle of the customer should be reflected in the choice of fabrics as well as in the garment silhouette. It is important to consider whether the fabric needs to be easy care, suitable for packing, stretchy, economical, or very comfortable.

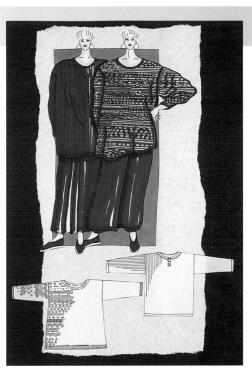

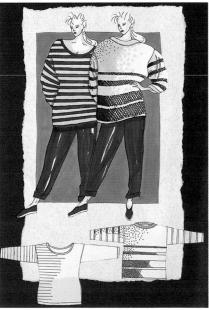

▲ Targeted presentation Commercial designs are often best represented by a clear and simple presentation style.

umit 17

Occasions, seasons, budgets

Now that you have begun to understand the lifestyle and aspirations of your customer, the next step is to refine your research still further and make your collection even more focused. A commercial designer will often focus on just one element of a client's lifestyle, perhaps for an eveningwear, lingerie, or swimwear range. It is also important to establish whether your collection will appear in the summer or winter, since this obviously will influence choice of fabric and garment style. The size of your client's budget is another important factor. There is no use creating a wonderful collection of garments if they are not affordable, and similarly, a customer with high aspirations will not want clothes that do not give off the right signals about status and wealth.

the project

Continue building the customer profile that you began in the last unit, focusing on certain specialized aspects. Also consider the season during which the customer will be wearing your clothes, and the size of the customer's budget. Sketch your rough ideas, stopping from time to time to revisit this initial research. Then finalize a collection of eight targeted garment illustrations.

the objective

• Take your research a step further to explore specialized aspects of the customer's lifestyle.

- Design garments that are appropriate for their end use.
 Consider season and budget.
- Channel your inspirational ideas into a commercially targeted outcome.

SEE ALSO

- Creating a cohesive collection, p. 82
- Planning a range, p. 88
- Customer focus, p. 94

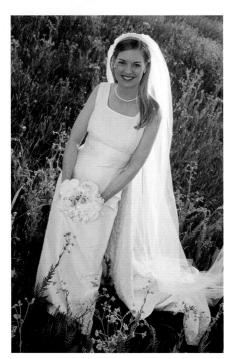

the process

Look back at the research you compiled in the last unit about the lifestyle of your target customer. Using words or found images from fashion magazines, continue to build up the story, this time taking the research further to encompass specialized aspects such as sporting or vacation activities, or special occasions such as parties or weddings. Should the garments be formal or casual? Are the fabrics you are using

Specific end uses

Swimwear made for the pool tends to come in performance fabrics and sportswear colors. Beachwear is more relaxed and often features playful patterns such as florals or animal prints.

Customer aspirations

A wedding outfit should always steal the show on the bride's special day.

appropriate to a specific end use? Sportswear, for instance, must be constructed from a fabric that performs well under extreme conditions and can withstand a great deal of washing.

Also consider the season. Are the fabrics warm enough for winter or can you make use of layering? Your ideas can be put to different seasonal uses; for instance, a shape created in boned satin for a spring collection could be re-created in thick wool for winter, or an embroidery idea on soft chiffon could be translated onto a heavy velvet drape.

How much your clothes will sell for will also dictate how they are made. Is there a great deal of handwork? Are the fabrics expensive? Will the garments have to be dry-cleaned? Would your customer be willing to pay more for all of these things? During production these kinds of factors are constantly revisited as pilot

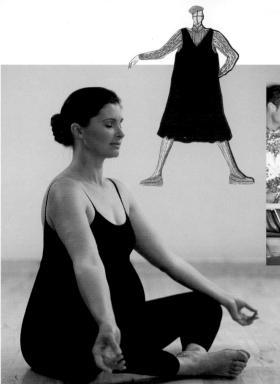

▲ Using special fabrics

Sportswear must stretch and mold around the body and should be easy to wash. The stretchy qualities of sports fabrics also make them ideal for use in fashionable maternity designs.

garments are produced and, if necessary, styles revised to allow the designs to remain within the appropriate costs.

Once again, check your ideas against the detailed customer research. Can you imagine your customer wearing these garments in the way that you intend? Finally, draw up eight finished outfits.

A Party style

A collection aimed at a younger age group might incorporate eye-catching fabrics and sexy, provocative styling.

A Nightlife choices

Female customers may want eveningwear to give an impression of glamor and sophistication, while male formal garments are often more sober. Remember to keep referring to your lifestyle research.

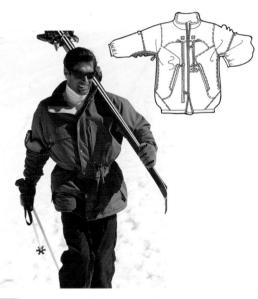

Technical innovations

Developing active sportswear can be very expensive because these pieces are specialized, incorporating high-performance fabrics.

SELF-CRITIQUE

- Have you truly gotten inside the mind and lifestyle of your target customer?
- Has the collection evolved toward your research and away from your personal taste?
- Looking back over your research, can you imagine your customer wearing the clothes in a real-life situation?
- Are your final designs truly appropriate for the occasion, season, and budget?

unit 17: showcase

t would be wrong for a student to start off with a predetermined set of restrictions; the emphasis of this book is on using research to spark ideas. However, once creativity has started to flow, it can be channeled into a commercial outcome. The last two units have been intended to help the designer with this channeling process, focusing first on creating a customer profile and then on taking the research even further to consider special end uses, as well as the constraints of season and budget. The cost of clothes to the customer is a particularly important factor although one that is often ignored by students. Designers create garments to be sold: if their prices are exorbitantly high, their collections will not sell. Anyone can create beautiful designs if money is no object, but it requires a talented designer to find the best possible creative solution within a tight budget.

The designs illustrated here show a strong sense of the target customer, and of where and when the client would wear the garments. The collections have credibility because they are well researched: they are stylish and original yet also consistent with the needs of the customer and the season, and could be sold at an affordable price.

V Occasional wear

These garments would all be suitable for a sophisticated customer, but would be worn in different ways, at a summer wedding, for example, or as smart workwear.

Thorough research

Producing work for a specific occasion and customer might require the compilation of a new, more targeted mood board.

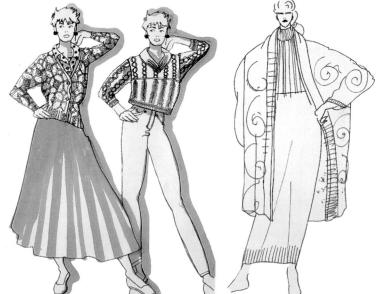

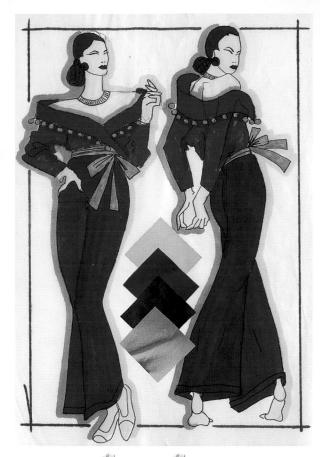

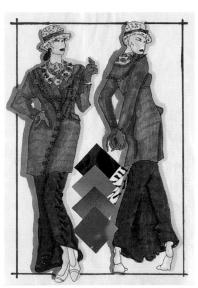

Thinking through the details

Designers have to consider how their garments will be worn. What accessories, such as hats or jewelry, might be required? Are the designs suitable for the season? Can the customer afford them?

Special requirements

Functional workwear may have a specific end use, perhaps with associated technical or safety requirements.

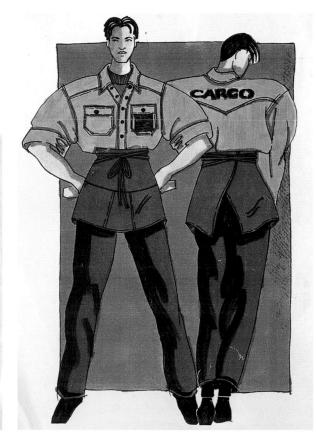

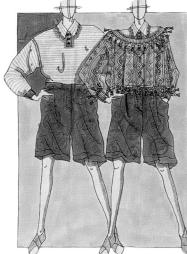

Work and play Work and weekend ranges targeted at the same person may be very different.

inspiration file

Color and fabric

Two of the most important factors influencing your designs will be your choice of color and fabric. The same shape or garment silhouette remade in another color or fabric will give a totally different effect.

Color palettes change from season to season. Not only do individual colors move in and out of favor, with brown becoming "the new black," but there are also subtle evolutions in the shades of colors used. Every designer needs to be aware of the predicted color trends for forthcoming seasons. The fashion industry shares this knowledge through trade shows, style web sites, and magazines-which is how similar ranges of colors appear in our stores each season as if by magic. The cynic might suggest that this is the fashion industry's clever way of encouraging sales, as customers dash out to buy this winter's red dress or pink sweater. However, the evolution is also a natural process. Fashion is charged with reflecting how people feel about themselves and the world around them, and just as themes and inspirations come and go, so too do color palettes. Fabric choice also changes cyclically because certain textiles move in and out of fashion and also because the properties of performance or warmth of different fabrics are strongly associated with particular seasons.

Fabric and silhouette cannot be separated. The drape and behavior of your chosen fabric will have a direct effect on the appearance of your garment. Imagine remaking an existing style in a different fabric. What would be the effect of its bulk, stiffness, transparency, softness, fluidity, or tendency to crease? Jeans made in satin or swimwear made of fur would become very different concepts.

You need to consider your choice of fabric carefully at rough-sketch stage. It is not enough to design shapes and then look for a fabric that will give you the right effect. Sensitivity to your materials and the development of shape should take place simultaneously because fabric and silhouette are dependent upon each other.

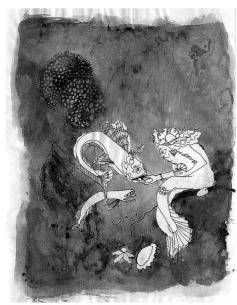

▲ ► Matching the source

You could try out color ideas by painting paper first; you may then wish to experiment with dyeing fabric to achieve the exact shade. The colors in this painting were reproduced as samples of dyed fabric, providing the basis for two sets of color selections (right), from which color palettes were later established.

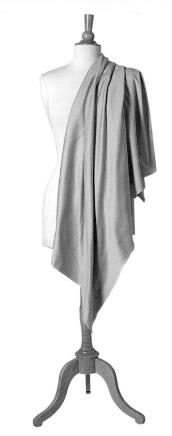

A Thinking in three dimensions

You should consider the behavior of fabric on the body right from the start of the creative process, so experiment by draping your chosen fabric on a stand.

Harmonious groupings

Gather samples of any fabrics, trims, and yarns that you are considering using to establish how different textures as well as colors will work together.

Using swatches

Comparing same-size fabric swatches will help you to see clearly the best combinations and also to judge proportions. Compare your swatch groups with trend predictions—are your color choices in line with current fashions?

Fabric and outline

Your choice of fabric will affect the construction of your designs. Soft fabrics, for example, can easily be encouraged to fall in soft folds across the body.

unit 18

Color palettes

A palette is a limited selection of colors that a designer uses in a collection to ensure that all the color elements sit together in a controlled way. Restricting yourself to a set of colors is an important part of the creative process: a garment or outfit can be totally reinvented by merely changing its colors.

The more colors you include in a palette the more challenging it is to use. A limited palette ensures that designs have a natural continuity. As a rule of thumb, novice designers should avoid palettes with more than eight colors. As you gain experience, the number of colors you use will become a matter of personal choice in keeping with your design style.

When creating a color palette, many students and designers use the reference books of tear-out color chips produced by Pantone. These uniformly sized color blocks are convenient to use and look tidy on a mood or presentation board. All the colors have individual reference numbers, recognized throughout the fashion industry, which you can quote when talking to clients, dyers, or manufacturers to avoid confusion about exactly which shades you mean.

the project

Isolate the important colors from your research and create color chips (or use the Pantone shades) to select a palette. Then use the palette as a focus while you are designing a collection. As you sketch out designs, vary the combination and proportion of colors used within the garments and outfits. Assess the balance of colors within the collection as a whole. Then create eight final

drawings, using the most successful color combinations.

the objective

Establish a working color palette.

- Vary the combination of colors to see how this affects the designs.
- Develop a collection with a successful color balance.

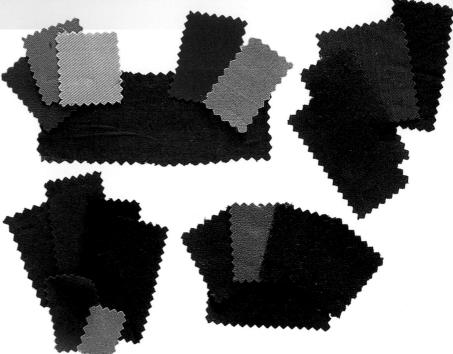

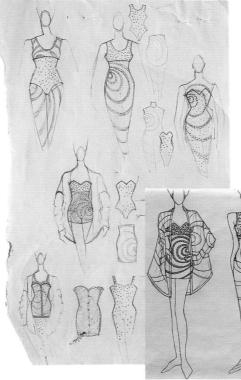

A Visualizing the designs

If possible, use color swatches made from the actual fabrics that you are considering using in the designs. This will give you the most accurate idea of how the colors will work together.

Experiment first

Working from your rough ideas, create simple outline sketches of your collection. These can then be photocopied a number of times so that you can try out various color combinations.

the process

Your mood board will suggest the important colors for your theme. Isolate these as color chips-either use Pantone chips or make your own from small squares of fabric, magazine cuttings, paint, or samples of yarn wrapped around a card. Use anything that shows a flat area of color, but avoid patterns. Start to group the chips into a palette, remembering that it is easier to use no more than eight colors.

It is very important to adhere to your palette as you sketch out your design ideas. Start by drawing roughs in blackand-white outline form; photocopy these and color each set differently, using your palette.

Dramatic color combinations produce exciting results, so be daring! Try using colors in different proportions. Combinations that work well in a palette can be ruined by an ill-considered use of proportion. For example,

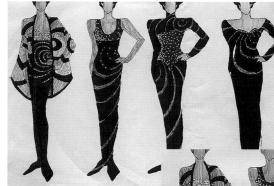

a black velvet evening dress with a side split can look fantastic with an occasionally glimpsed red lining. However, the same dress in red and

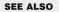

- Mood boards, p. 26
- Designing fabric
 - ideas, p. 40

black stripes would not be at all as sophisticated.

Always keep your research in mind and try to evoke a similar use of color in your designs. Finally, draw eight outfits, using the best color combinations from your rough experiments.

Playing with proportion

Varying the proportion and combination of colors can give a strikingly different look to the same design. Try out a number of variations.

▲ Color consistency

Finally, pick out those designs that create the strongest effect. Be careful to ensure that they sit well together as a collection and are all still relevant to the original palette.

SELF-CRITIQUE

- Have you established a focused and workable color palette?
- Do you see a link between the colors in your research and those in your final designs?
- Is the balance of colors in your collection effective?
- Has the palette been used successfully in the designs?

unit 18: showcase

E stablishing a color palette first and then using it in the generation of roughs and final drawings ensures a consistent set of designs, as demonstrated here. Adjusting the proportion of colors can put a new spin on an illustration, giving it an individual feel while still tying it into the collection as a whole through the use of a common palette. Even more dramatic effects can be achieved by applying an entirely new color palette. These illustrations could be recolored by scanning them into a computer and substituting new colors, by feeding the outlines through a color photocopier and adjusting the color balance, or by redrawing or photocopying the designs and repainting them. Changing the color palette will alter the whole look of a range: the same floral design might be colored in greens for a high summer jungle story, in pinks for a spring feminine theme, or in blue and white for a nautical feel.

◄ ▼ Judging the effect

The most accurate way to assess color combinations is to experiment with samples of the actual fabrics that will be used. Colors may appear differently, depending on factors such as the thickness of pile, how matte or shiny the fabric is, and decoration like sequins or beading.

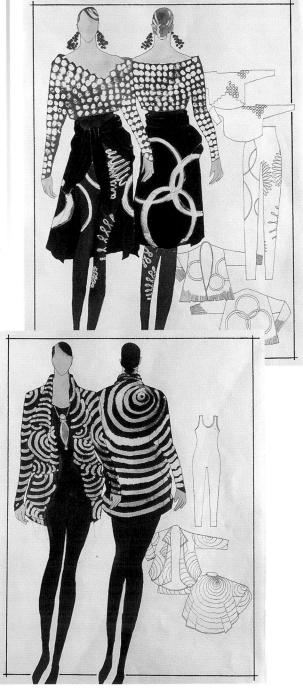

◄ ▼ ► Variations on a theme

These final illustrations reflect the original palette, although the proportions of colors used have been varied from garment to garment to give each one an individual identity.

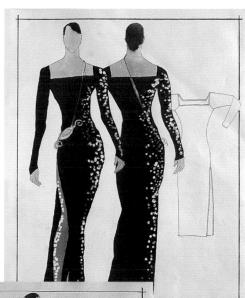

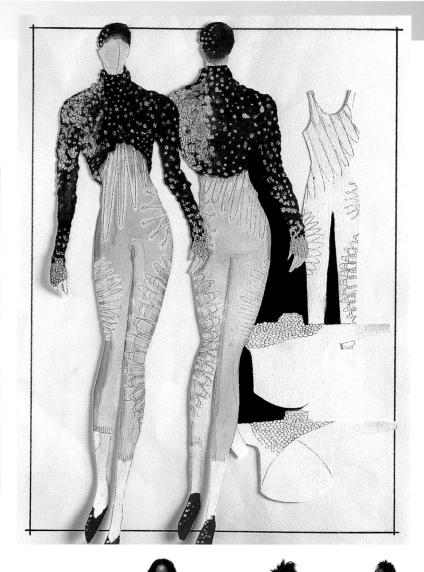

Breaking the rules

Cohesion is a positive foundation for a palette, but adding a surprising splash of color in an unexpected shade can lend a sense of drama to a design.

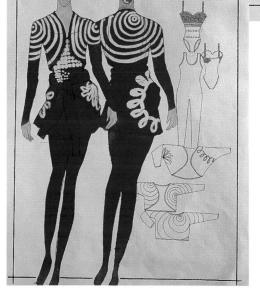

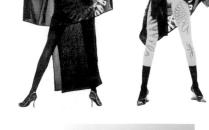

umit 19

Structuring fabric

▲ ✓ / e have seen how important choice of color is to the outcome of a project. Fabric has a similar impact and needs to be as carefully considered. Unit 6 (pages 40-43) discussed how a fabric embellishment idea can be the focus for a design; this unit will look at how the structuring of fabric can drive garment construction, whether through methods such as pleating, draping, or binding, or through the creation of entirely new fabric structures using techniques such as crochet, knitting, or appliqué. As you gain experience, you will see how fabrics have particular properties and behave in very different ways. You need to learn to harness the inherent properties of fabrics, whether you are working with clinging jersey, chunky knits, or highperformance sportswear. As your confidence grows, you will want to control the effect of fabric from the earliest stages of the design process. Then, rather than relying on store-purchased textiles to fit your theme, you will be able to manipulate fabric to dictate the volume and shape of your garments, as well as their surface appearance and texture.

the project

As you put together a mood board and color palette, experiment with structuring fabric to create a silhouette. Explore your ideas by manipulating paper; then consider how these ideas can be transferred onto fabric, either through techniques such as pleating and draping or through methods that create an entirely new fabric structure. Choose the strongest roughs to create a final collection that incorporates your fabric structuring ideas.

the objective

 Take an active role in fabric manipulation.
 Develop structuring ideas that drive your designs.
 Ensure your fabric development is in line with fashion trends.

the process

Gather research images using drawing and photography, and identify the key shapes and structures. Treating your

SEE ALSO

- Designing fabric ideas, p. 40
- Color palettes, p. 104

page as a piece of fabric, start to sketch out structuring ideas. Don't worry at this stage about the practicalities of achieving the effects; just let your imagination run wild. Still working on paper, experiment with methods such as gluing, stapling, hand and machine stitching, cutouts, and appliqué. Remember that you are

Analyze your source Choose a source, like this biker theme,

that will inspire ideas about texture, volume, and construction to guide you when structuring fabric to create a silhouette.

looking for ideas that will support the construction of the garments.

Now think about how these first thoughts can be translated onto fabric. You could create a fastening using fabric ties. Stitching and gluing could be the means of structuring a finished garment or might provide seaming ideas. Layering, pleating, and draping are all ways of creating volume in a garment. You might consider how cutting fabric on the bias (placing pattern pieces at a 45-degree angle to the fabric selvages and grain) would affect structure. Bias-cut fabric has far greater drape than usual and clings to the body in a very flattering and feminine way when used in skirts and dresses.

You could even build up a completely new fabric, using techniques such as crochet, patchwork, or knitting.

Remember to keep an eye on the work of other designers. All these wonderful effects should not distract you from the fashion overview.

Finally, select your strongest roughs to use in putting together a collection of finished designs structured around your experiments in fabric manipulation and distortion.

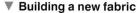

You can structure fabric by attaching small pieces together to create an overall design. Explore these ideas on paper.

Fashionable use of fabric

It is important to keep a close eye on what is happening to fabric structuring within the world of fashion. What are the other designers doing? What are the key trends? Such considerations will stop you from becoming overly self-indulgent.

SELF-CRITIQUE

- Have you created unique and original structuring ideas?
- Does your fabric manipulation reflect your research?
- Are the fabrics appropriate to the fashion silhouettes?
- Are your concepts disciplined and truly fashionable have you avoided being self-indulgent?

unit 19: showcase

The construction of these garments has been driven by the structuring of fabric, whether through the building up of new textiles or the manipulation of existing fabric to create volume and shape. Thinking about how fabric will behave when shaped into a garment naturally leads to a more detailed consideration of the garment itself. Designers need to be aware of the structural nature of different fabrics and incorporate them into their fashion ideas accordingly. Bulky knitwear, for example, can be designed only into certain shapes, and is bound to be heavy and hot. Clinging jerseys, on the other hand, will mold around the body, and fine velvets will drape into soft folds. The behavior of fabric can be explored by molding samples around the curves of a dressmaker's stand, or around a real body, using a volunteer. If the fabric has a complex structure—an ornate crocheted pattern, for example—it is important to remember that the silhouette should be kept simple in order to avoid a confused overall effect.

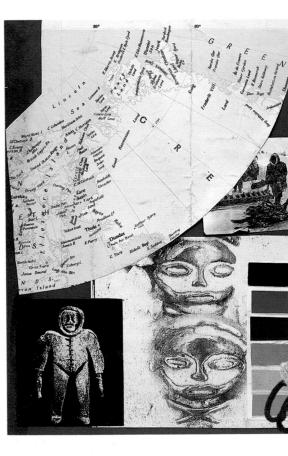

◄ ▼ Driving the design Structuring ideas inspired by this Arctic theme include knitted snowflake stitches and the use of chunky fabric to create a bulky, hooded outline (shown below right). Thorough research will yield ideas about volume, shape, and proportion.

Structure and embellishment

Knitted stitches can be used to give the garment volume as well as surface decoration.

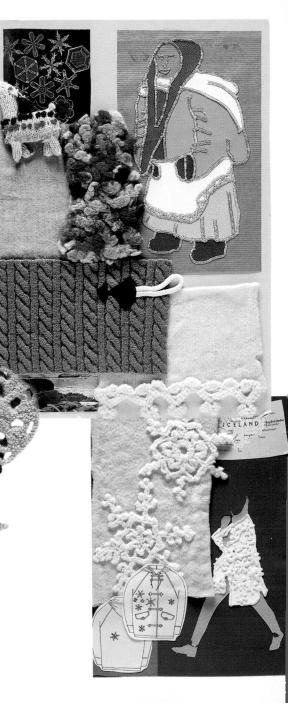

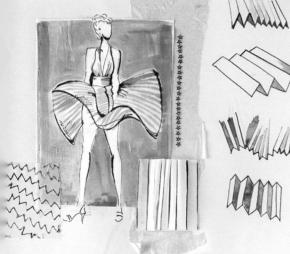

▲ ► Volume on the body

Methods of fabric manipulation such as folding, pleating, and draping can be used to give volume and shape to relatively simple fabrics.

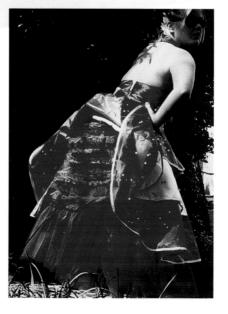

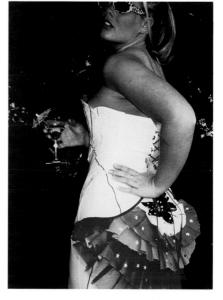

chapter 4

COMMUNICATING YOUR VISION

The most wonderful ideas and stylish drawing techniques will count for nothing if you cannot present your designs effectively. This chapter explains how to support your illustrations with flat working drawings and represent your ideas as threedimensional garments. You will also learn how to create professional-looking presentation boards, to choose the most appropriate illustration style for your work, and to communicate your vision clearly, accurately, and with maximum impact.

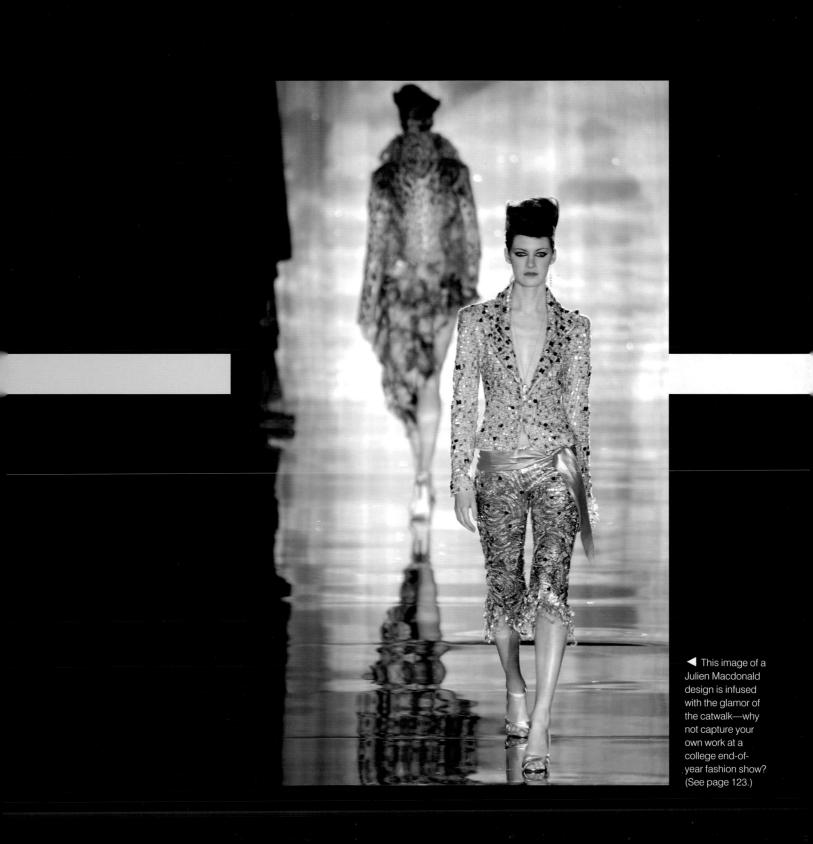

inspiration file

Clarity and communication

It is important to remember, when you illustrate your designs, that you are making abstract concepts from your imagination real to other people. Your fashion drawings may be very creative and evolve into works of art, but it is important that they can still clearly and accurately describe your design intentions. When you show your ideas to a client or a pattern cutter, they must be as clear about your designs as you are.

This does not mean that you have to sacrifice creativity. Depending on your style of drawing, your work might be unambiguous or somewhat open to interpretation. Look critically at your finished drawings and decide whether or not they will be absolutely clear to a first-time observer. If you are in any doubt about clarity, it is best to support your illustrations with flat working drawings.

You will hear these types of drawing referred to in different ways: flat drawings or "flats," specification drawings or "specs," technical drawings, or working drawings—or any combination of these terms. As the names suggest they are accurate, clear, and easy-tounderstand representations of your design ideas. Rather like the plan for a house, they should faithfully represent every aspect of your garments. Occasionally these drawings are even made to scale, but this is not necessary (and measurements are also not always expected). So long as they accurately describe how your garments are constructed, and include any necessary design details, working drawings will successfully support your more creative illustrations. As a commercial designer, working as part of a team, clear communication will be paramount, and you will often find yourself dealing mainly or even wholly with working drawings. Fortunately they are very quick to complete, with a little practice.

Keep it simple

If you are working with very textured fabrics, such as those pictured here, you need to maintain a balance between depicting that texture and keeping your illustrations clear. Inspirational material can be included on a presentation board to reinforce the mood of the collection, but avoid overloading the board with so much detail that it becomes confused. You will find that undertaking these kinds of drawing is a useful discipline that will benefit your creative process. Making working drawings will force you to be crystal clear about your intentions, to provide precise proportions, and to make decisions about positioning and type of seam, pocket, fastening, and neckline—clarifying all those details that are so vital to the design of beautiful clothes.

Conveying texture

These garments all feature interesting textural detail that might overload a garment illustration or working drawing. One way to display texture is to mount fabric swatches (like those illustrated left) separately from the garment illustrations themselves.

▲ ► Providing the detail

Flat technical drawings help to clarify how the illustrated garments are constructed. They can also define exactly how and where surface pattern or stitch texture is to be placed on a garment.

THEFT THE THE TAXABLE PARTY OF TAXABLE PAR

unit 20

Working drawings

Creative final illustrations of your collection will often need to be supported with clear and accurate flat working drawings. This will allow you to be artistic in your illustrations, knowing that they are supported by technical drawings that provide an unambiguous and precise description of your garments. Your working drawings should record exactly how your clothes are to be constructed, and how all the details, trims, and finishes are to be applied. Completing them will force you to make decisions about these factors, which might otherwise have been left open to interpretation. You will be surprised at how the process of making working drawings forces you to think more deeply about your designs.

the project

Look through your wardrobe at home and pull out a range of different types of garment. Lay them out neatly on the floor so that you can observe every detail. Photograph the garments so that you start to relate to them as flat illustrations. Try representing what you see as accurate flat line drawings that clearly describe the construction of the garments and their details. Then practice by making working drawings of your previous illustrations.

the objective

- Assess critically the construction of existing garments.
- Practice making drawings that accurately describe the proportion, makeup, and details of your garments.
- Apply what you have learned to the exact description of previous design illustrations.
- As a result of this process, think in more detail about your designs.

With practice you will become comfortable with making clear and accurate flat "specs." Keep designs on file as you complete them you can trace over them for future projects.

Practicing at home

Your own wardrobe at home can provide ample opportunity to practice working drawings. Garments can be laid out flat, or placed on a garment stand and then represented as flat sketches.

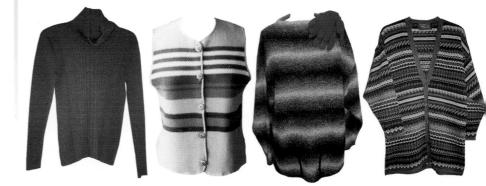

the process

Select a range of your own garments. You could even buy a few items from a charity store and take them apart to investigate their construction. Work with five garments, choosing a variety of difficult pieces.

You need to be able to look directly down on the clothes from above, rather than at an angle, so lay them out on the floor instead of on a table. Lay them out as simply as possible, with no creases. Avoid overlapping sleeves with garment fronts; either place sleeves to the sides or fold them over on themselves. Take photos of the laid-out garments. These will be easier to draw from and will help you relate to the clothes as flat shapes.

Using a fine black felttip pen and working on a layout pad, start to draw

exactly what you see. The first few drawings will take the most time to complete. After that you can place one of the initial drawings underneath each fresh page in your pad to use as a starting point as you sketch the next one. This will save you time as you draw the collection, ensuring proportions are kept the same and emphasizing similarities of outline that will give the selection of garments cohesion as an illustrated collection. Remember to describe every aspect of the garments, including their proportions, seam details, trims, pocket

positions, necklines, and sleeve and body shapes, as well as front and back views. You can outline your drawings with a slightly thicker black pen to highlight the garment silhouette.

If you are finding it difficult to get going, start by tracing in pencil over your photographs and then work over the pencil outlines in pen. In this way you will build up a set of drawings that you can use as a foundation for other drawings.

Finally, refer to your previous creative illustrations and make working drawings of these. As you take the

SEE ALSO

- Practicalities of presentation, p. 126
- Presenting with flair, p. 134

working drawings back into the creative process, using them as a basis for further developments, you will deepen your understanding of your own designs.

When figures are needed

Sometimes details such as necklines need to be represented on the body so that the exact scale and proportion can be shown.

Not always necessary

Some fashion illustrations might not need to be supplemented with additional flat drawings. If they are clear and unambiguous, they can communicate your design ideas sufficiently on their own.

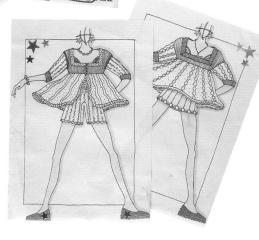

SELF-CRITIQUE

- Have you chosen a challenging range of garments to draw?
- Have you described every aspect of their construction and detailing successfully?
- Show your drawings to someone else and ask them to describe what they see. Does this description match the real garments?
- Do your working drawings describe your designs more accurately than your creative illustrations?

unit 20: showcase

With practice, working drawings can be produced with great speed. As the illustrations here demonstrate, they are very useful either mounted on a presentation board, giving details that might otherwise have cluttered up the illustration, or as part of the creative process, representing existing garments to provide a basis for related but original designs. Traced over on a layout pad, working drawings can be used in the same way as figure drawings to generate ranges of ideas. The ability to make working drawings is a useful skill for a designer to show in a portfolio, because commercial designers are more likely to work with this type of drawing than any other. Clarity and accuracy are the goal. Working drawings should communicate effectively the precise construction, proportion, and embellishment of the design, so much so that they could be handed over to a pattern cutter or machinist in the confidence that the ideas will be re-created exactly.

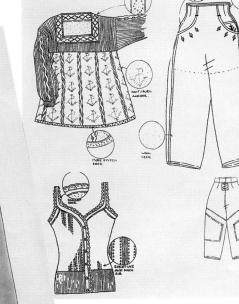

Supporting creativity

These working drawings provide the details, enabling a more creative depiction of the smocked top.

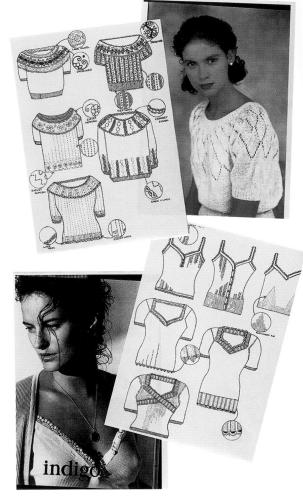

Reinterpreting existing designs

Using flat working drawings to represent garments featured in fashion magazines may inspire the creation of a range of related but original pieces.

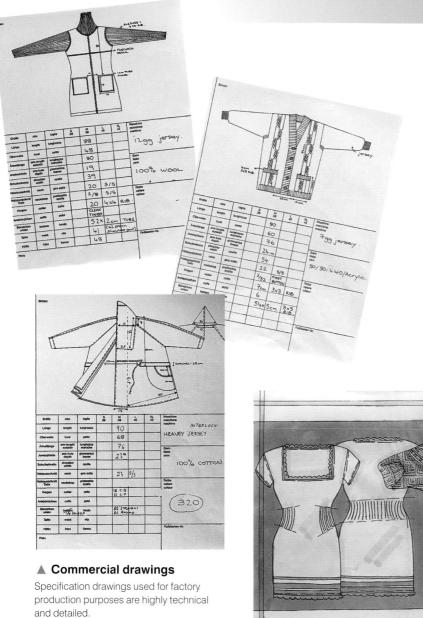

▼ Scale and proportion

Designers do not always provide measurements for working drawings. It is usually more important to ensure that the representations are to scale and in proportion.

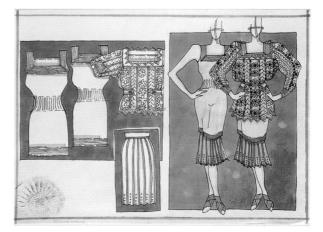

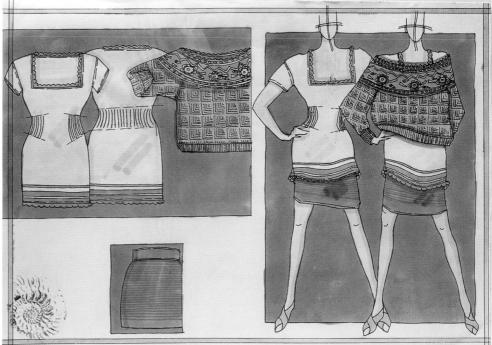

unit 21

Real garments for your portfolio

This project will allow you to present your designs as three-dimensional garments. We are not dealing here with the technical aspects of garment construction—that is an involved topic that would fill another book. However, you can still represent a design as a finished piece by mocking up a garment that can then be captured with photography. If you have actually made up any of your designs already, then you will be able to practice styling the garments so that they can be photographed to best effect.

You will find this project to be a wonderful learning experience that will add to your creativity. The best way to learn about garment construction is to practice taking apart and making up real items. You will then become familiar with the shapes of pattern pieces, and methods of seaming and finishing. Draping fabric on a dressmaker's stand is another route to garment design, involving observation of how the fabric actually behaves on the body (which can only be imagined at the sketching stage). Some designers work best in this way and start by draping fabric before they even pick up pen and paper.

the project

Select some design illustrations that you would like to represent in garment form. Wrap fabric around a dressmaker's stand or model to create an impression of finished garments that you can capture with photography. If you have already made up garments from some of your illustrations, experiment with different ways of styling clothes and photographing them.

the objective

- Represent real garments in your portfolio.
- Practice styling your designs on a model or a stand.
- Develop design ideas by draping fabrics or garments on a model or a garment stand.

the process

Start with a length of fabric draped over the stand or body and manipulate it as the design dictates, by folding, tying, stretching, binding, or gathering. Aim to mimic the way the fabric would behave on the body if it were constructed as a garment. Pieces can be cut away or pinned in place as the shape of the garment is evolved, but this might not be necessary. Alternatively, experiment with styling

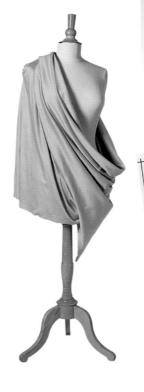

and photographing garments that you have already made up.

While you are working, keep your mind open to new ideas, because the process of folding and draping will encourage you to develop new design solutions. For example, as you are creating pleats of fabric as suggested by an illustration, you might notice that the folds create a scalloped edge on a sleeve, or a drape of fabric over the hips, in a way that you had not anticipated. These sorts of ideas can be incorporated into the range and used on other garments, or reconsidered and exaggerated within the existing designs. They

might even become more important than the original concept. Alternatively, they can be noted down for use in a future project.

Style garments with flair to represent the spirit of the design illustrations. Try out as many options as possible to display your work. You could arrange garments on a model, a stand, a hanger, laid flat on the floorclothes have even been photographed on a dog! Experiment with different options and be as creative as you can. Keep in mind what you are trying to achieve: the positive representation of your design concepts.

Capture the mood

Photographs of finished garments should reflect the mood of the source-inspired final presentation.

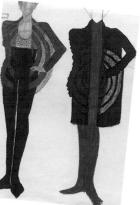

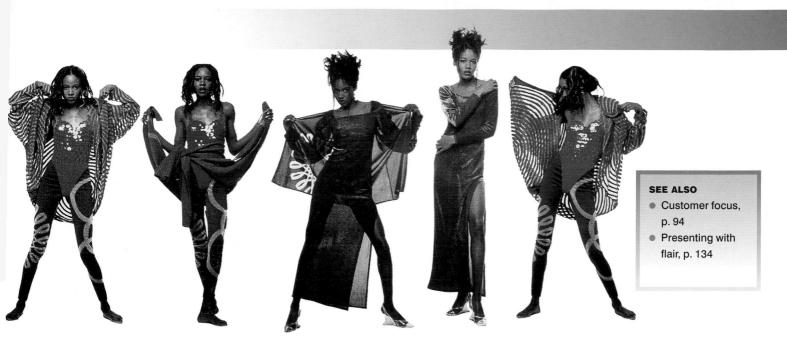

▲ Teamwork

Why not team up with other students? These photographs were the result of a collaboration between a fashion student, a photography student, and a young model. The images were used in all three portfolios!

Styling garments

Experiment with different ways of styling and accessorizing the clothes on the stand. Consider using items such as jewelry, or hats and gloves.

SELF-CRITIQUE

- Were you either too ambitious or too safe in your choice of drawings to mock up or finished garments to style?
- Have you used a wide range of methods to mock up and style the garments?
- Do your photographs successfully capture the proportions and styling of the garments?
- Have you avoided amateurish presentation?

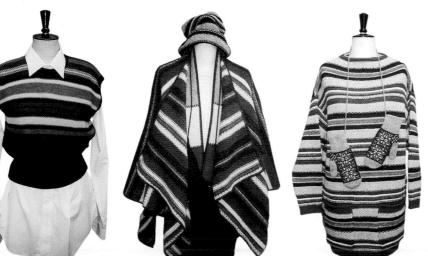

catwalk

If your college has an end-of-year show, be sure to capture your designs on film and then mount these images for your portfolio.

unit 21: showcase

Photographs of three-dimensional garments, either real or mocked up, take fashion illustration a step further and allow the representation of finished pieces in a portfolio. As shown by some of the images here, the photography does not have to be particularly "arty" to show off the designs to great effect. Using video or still photography to capture designs as they come down the catwalk at an end-of-year event will give their presentation the feel of a top fashion show. Pieces displayed on a stand or draped around a body can sometimes be best photographed through closeups of garment sections rather than through a styled photo shoot approach that could look amateurish if the quality of the photography is not very good (another option is to collaborate with a photographer). The use of a digital camera can be productive, allowing the images to be further manipulated with a computer. The digital editing process can result in new design ideas as well as in creative presentation.

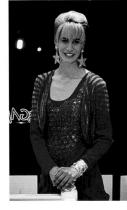

Intriguing shots

Photographing designs in different locations and using a mixture of closeup and long shots adds variety and interest to the presentation.

Letting go

Successful collaboration with a photographer involves relinquishing control over the portrayal of the garments to a certain extent, and allowing the photographer some creative free rein.

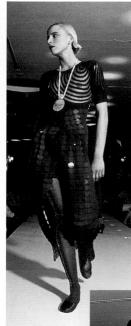

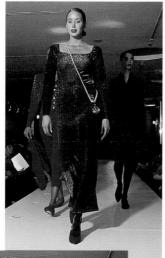

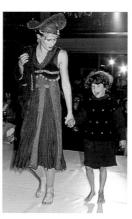

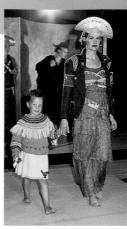

◄ ▲ ▼ Options for presentation

Catwalk photographs can be either mounted as a separate series of images or combined with illustrations to make integrated presentation boards.

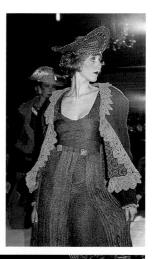

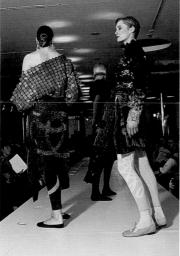

▲ The glamor of the show

The excitement and glamor of a college catwalk show will show off your garments to stunning effect. Using either still photography or a video camera, professional-looking images can be achieved.

All the angles

A styling detail such as this one on the back of a garment should be captured on film, too.

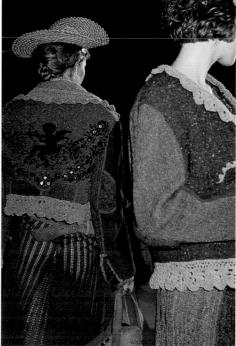

REAL GARMENTS FOR YOUR PORTFOLIO 123

Presenting your work

Fashion designers are in the business of visual communication, and effective presentation of work is all important. Your brain may be teeming with innovative ideas and you may produce the most original designs, but none of this will matter if you are unable to communicate your vision. In the fashion business, first impressions really do count. When you show your work, you need to ensure that your presentation looks as professional as possible—organized, well mounted, and clean, as well as accurate, clear, and creatively appropriate.

Your illustrations can be mounted on foam boards or on card (the boards are sturdier but can be bulky to transport), both of which can be bought from art supply stores. Boards are available in various sizes and your choice will be influenced by factors such as personal preference, your audience (if you are presenting to a large group the board must be big enough for them to see), the trend of the moment (which could equally be for very large boards or pocket-sized presentations), or the size of your illustrations or portfolio. With experience you will find the size that suits you best, but start by using a 20- x 30-in. board, and be prepared to try out different options. Avoid using a combination of different sizes, which can make your portfolio seem messy.

It is worth emphasizing that the work you present should be clean. Carrying a portfolio around, it's easy to get finger marks on the boards and for card edges to become tattered. Make sure that your presentation is always fresh. Even recycled ideas can have a market if they look as if they have just been produced.

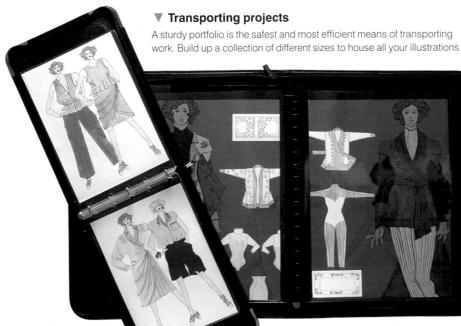

Displaying work

Mount work on board or card, or use a plastic folder. Factors such as the size of your illustrations and portfolio will influence your choice of size and color.

A sturdy portfolio is essential. A selection in different sizes can be useful; you can store work in some and keep others for showing presentations. Make sure that your portfolios are relatively easy to carry, even when laden with work. For protective storage, plastic envelopes are invaluable. If used in presentation, plastic will reduce the picture's color slightly and give it a glossy sheen. Sometimes this can enhance the illustration, but if your artwork looks better matte, don't present it this way.

You will also need to choose carefully your style of illustration as well as your approach to the presentation as a whole, to ensure that

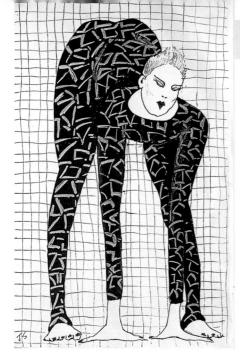

work is shown off to best effect. If your designs are very delicate you might want to use an ephemeral style of drawing to capture them on paper, perhaps accompanied by flat working drawings. The delicate feel of your designs would then also influence aspects such as the use of color, the choice of fabrics, the style of photography, the poses of the figures, and the arrangement of all these components on the board. In this way, all the elements of a presentation will be working together to promote your ideas.

Beware of trying too hard with finished sheets. You can always use a color photocopier to tidy up an exciting but possibly scruffy example of work from your sketchbook, which was produced in a flurry of creativity. Sketchbooks offer a good glimpse into the soul of your work. You may not always want to reveal this to a client, but sometimes it may help to convince them of the creative journey that has produced the finished ideas.

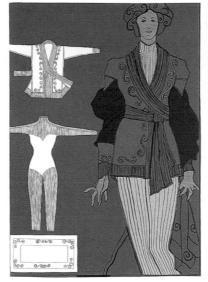

▲ Simplicity

You don't have to include fabric swatches or working drawings on your board sometimes it's best just to let the illustration speak for itself. Working drawings allow a more artistic depiction of the garments, while a colored background can be effective (this one sets off the rich, sober design palette of the garments). Be careful, however, that the color does not overwhelm the illustrations.

lille als

infai

▲ ► Harmony

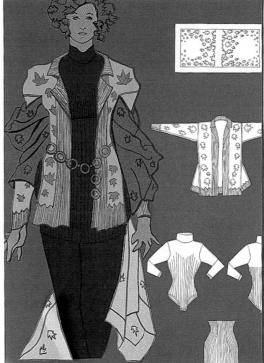

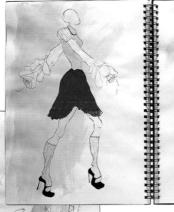

Work-in-progress

Ideas in sketchbooks often have a liveliness that can be lost in finalized work. If presenting your sketchbooks, make sure that there are no sharp objects (such as staples) to take the viewer by surprise.

PRESENTING YOUR WORK 125

unit 22

Practicalities of presentation

Embellishing work with unnecessary extras can show a lack of confidence in the main concept, so whether you feel your designs call for an understated presentation or for a more elaborate themed approach, you must be sure that you don't include anything that does not contribute to the impact of the designs. You want someone seeing your illustrations for the first time to be struck by the quality of your design statement—not by the decoration surrounding it. A simple presentation has more chance of being successful, and will not offend anyone's tastes, although a more creative presentation style can create a strong impact (see Unit 24, pages 134–137). Decoration such as edgings must never overwhelm the illustrations, and colored backgrounds should be used only if they complement the design palette. Include items such as working drawings and swatches if they add to the clarity of the presentation, and remember that your work should appear clean and tidy.

Do not use spray mount to stick your images to the board, as this can cause respiratory damage. Dry-mounting images is a safer technique that involves placing a sheet of adhesive backing onto an illustration and then heating in order to adhere the image to the board. However, this is a laborious process and it is simpler and quicker to use an adhesive stick or double-sided mounts.

the project

Select a few of your favorite illustrations from the same project to mount on a 20- x 30-in. board or boards. Don't worry about achieving a very dramatic style: this unit is about practicing well-organized, tidy, and effective presentation. Include items like fabric swatches if you wish, so long as the images are not obscured. You should choose and arrange your illustrations to reinforce the impression that they are part of a cohesive collection.

the objective

 Include items that contribute to the impact of your designs.

Create a professional presentation.

 Present designs in a way that makes them look like part of a cohesive collection.

the process

Select a few designs to present from the same project. Before mounting, you may want to crop them to remove tattered edges or make the composition more focused. Use a scalpel and ruler or a guillotine. Clean up any smudge marks with a soft eraser. **Reproducing illustrations** in a different medium may give a more professional finish, so consider taking photographs or making photocopies. You could even scan the pictures into a computer in order to further manipulate the designs, and then print the results.

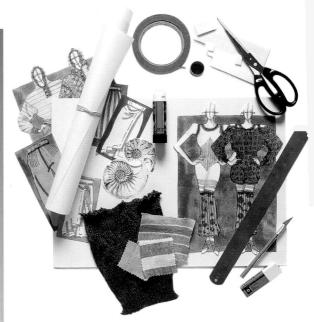

Mounting illustrations

A board can be built with simple tools: a craft knife and ruler (for cutting straight lines), scissors (for cutting curves), and sellotape, adhesive stick, and peel-off mounts (for attaching work).

Drawings that have been made using charcoal or pastel will smudge if they are not treated. Spray them with a fixative according to the instructions on the can. For health reasons, it is best to spray outside. Never sign your illustrations as if they were finished works of art. However good they are, your drawings are

SELF-CRITIQUE

- Is your presentation bold and not too busy?
- Is the work neat and clean?
- Will a viewer understand the design story?
- Is the board practical for you to take to a client?
- Could you have presented your illustrations differently to greater effect?

not ends in themselves but commercial representations of ideas for garments.

You can mount your work straight onto the white foam board or stick down a sheet of thin card as backing first. One (expensive) option is to cover the board with hand-made paper with ragged edges and then mount straight-edged illustrations on top of that. Alternatively, you could use a board exactly the same size as the illustration, so that no background shows at all. Resist trying to be too clever with your mounts. A controlled use of borders can help to give a more defined presentation but if in any doubt keep it simple or avoid them altogether. Colored paper can work as a backing for designs in a complementary palette, but be careful that the use of color does not detract from the image itself.

You don't want to overload your board, but clarity can be added with items such as fabric swatches (if your textile is complicated it is better to display the detail with a small sample rather than trying to capture it in the garment drawing) and flat working drawings.

Decide how many illustrations you want to include on the board and, before sticking anything down, arrange all the illustrations and other items. Don't try to cram on too much information and don't overlap the illustrations so much that you can't see the designs. If you are presenting on more than one board, you can repeat color and composition to give the group a cohesive feel. Start sticking down the images only when you are happy with the overall composition. The easiest way of attaching items to a board is by using adhesive stick or peel-off double-sided mounts. The advantage of peel-off mounts is that they make removing images simpler if you decide to remount them.

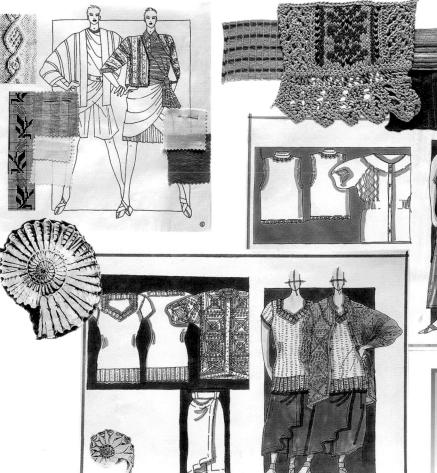

Clear and cohesive presentation

Convey information about fabrics using small swatches or drawings to avoid overcomplicating the garment illustration. Multiple boards can be given cohesion through a common composition—both of the

boards below feature two figures in the same position and pose, with an identical positioning of creative illustrations and working drawings.

SEE ALSO
Choosing a presentation style, p. 130
Presenting with flair, p. 134

unit 22: showcase

The images featured here demonstrate that effective presentations can be either boldly simple—featuring only the garment itself and focusing on color and silhouette rather than on detail—or complex, incorporating fabric details, for example, that may be as prominent as the garment itself. Much depends on personal taste as well as on the nature of the garment: if the interest of a piece lies in the textile then the portrayal of this aspect will be important. There are certain ground rules, however, that apply to every type of presentation. They should be strongly composed (as here), with the viewer's attention drawn immediately to the central concept—whether that is a jacket, a whole outfit, or a combination of fabric and garment. Presentations should also always be neat and clean, and give the impression that they have been professionally produced. Multiple presentations representing different pieces belonging to the same collection should be given cohesion through the repetition of aspects such as the composition, the use of color and decoration, and the positioning and pose of the figures.

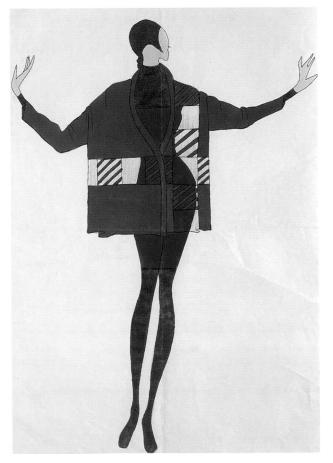

Strong statement

This bold design is best presented in a confident, understated way there's no need for swatches, working drawings, edgings, or any other embellishment.

Repeating the motifs

These illustrations go right up to the edge of the board so that no background is visible. The presentation emphasizes the cohesion of the collection through the use of a repeated pose.

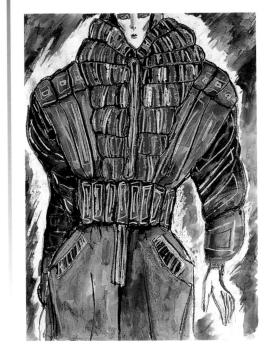

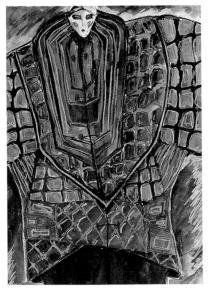

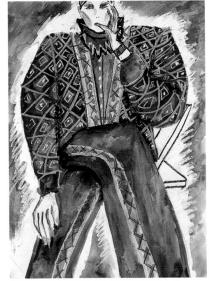

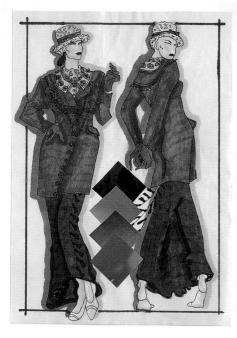

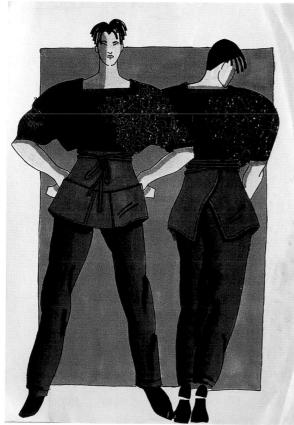

◄ ♥ Using borders

Borders can be successfully used to add definition to a presentation. Illustrations can be framed within thin lines or wide edgings (as below), but this sort of decoration should only be applied if it does not diminish the impact of the design concept. Borders would seem too busy around a complicated print design, for example, which would be better presented on a plain white background.

▼ ► Complex boards

Here, every item contributes to the design story—showing the texture of the fabric, the style of the garment, and its technical detail. Small examples of inspirational material can be included if, as here, they are not obtrusive and contribute to the mood of the piece.

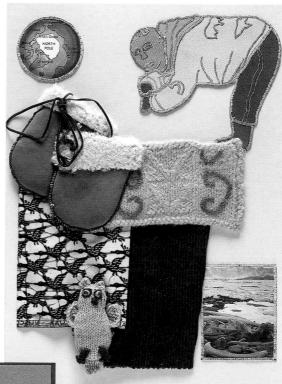

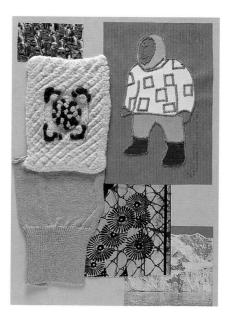

unit 23

Choosing a presentation style

• ompleting a number of presentation boards, each I showing garments illustrated in a different style, will help you show off the versatility of your work to best advantage. This unit is intended to help you choose illustration styles that are appropriate for your designs and that will present them in their best light. You should choose a style of final illustration that both conveys your original inspiration and reinforces the design ideas, without taking over from the garments themselves. For example, if you have drawn inspiration from a natural source such as a shell, you might want to replicate its soft colors and delicate lines in your illustrations. You would also need to consider the nature of the garments themselves-neither a very bold nor a very painterly style would be suitable for illustrating a more conservative, commercial design. Try to use a different style of presentation for every project. By varying the flavor of each board, you will ensure that you build up a diverse body of work to appeal to a range of clients.

the project

Gather together inspirational research, mood boards, and rough sketches from some previous projects. Consider how appropriate the styles of drawing are to the original themes. Then experiment with different methods of illustration, inspired by your research and roughs. Support the designs with technical drawings, fabric swatches, and color swatches where appropriate.

the objective

- Draw designs in the method that shows them to best advantage.
- Challenge yourself by varying your presentation style.
 - Create presentation boards that will give your portfolio impact and variety.

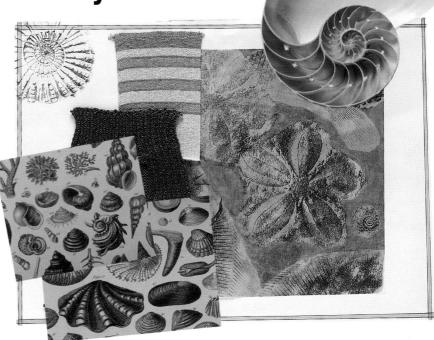

the process

Lay out all the elements of your chosen projects in a large space, including rough ideas, research material, and any mood boards. Place images side by side and compare the designs (if your work is in a sketchbook, photocopy the pages for this purpose). Reconsider the methods by which you have drawn (or intended to draw), your finished designs. The most appropriate illustration method will be closely tied to the level of detail

that you need to show for each design.

If transparent layers are an important feature, illustrations might involve subtle color washes to suggest the see-through nature of the fabric. However, you would need to show more detail where garments include print or embroidery. It is not necessary to map out every stitch-this can be done on the flat working drawings (see Unit 20, pages 116-119)-but your illustrations should show the scale and position of the decoration.

First inspirations

Let your research guide you in choosing the most suitable method of illustrating your designs. An effective presentation goes beyond accurately depicting the garments: it sums up the whole mood of a collection. The fine lines and natural colors of these shell images might suggest a precise, delicate style, perhaps using watercolors or pen and ink.

SEE ALSO

- Clarity and communication, p. 114
- Presenting with flair,
- p. 134

Look to your research for clues about the best style of illustration to depict your designs. A soft feminine theme might require a painterly approach, whereas a modern theme might find you scanning images into a computer and manipulating them with illustration software. Think creatively and aim to build up a varied set of styles within your portfolio to illustrate your flexibility and adaptability.

To communicate your design concept clearly (especially if your work is very painterly), consider including items such as working drawings, samples of fabrics or yarns, or even small examples of inspirational research material. Do not be tempted to overload the board with too much information or the clarity of the presentation will suffer.

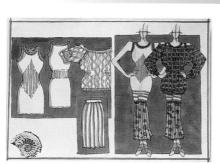

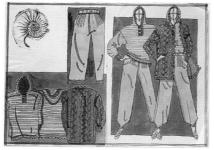

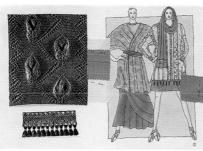

Elements of a presentation

In addition to displaying the illustrations, the presentation should include whatever is necessary to communicate the designs clearly, whether that is flat technical drawings, fabric swatches, trims, color palettes, or examples of inspirational material.

SELF-CRITIQUE

- Have you successfully experimented with different styles of illustration and final presentation?
- Does the style of illustration show off each design in its best light?
- Have you achieved a balance between clarity and creativity?
- Do you have professional presentations to add to your portfolio?

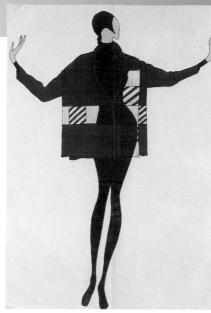

Focused presentation style

Think carefully about the mood that you are trying to convey. Dramatic designs can be communicated effectively in a bold style, whereas a more commercial look may demand a more traditional approach.

A balanced style

Remember to balance the creative effect of your presentation style with the need to accurately represent the fit of the garments and the textures of the fabrics.

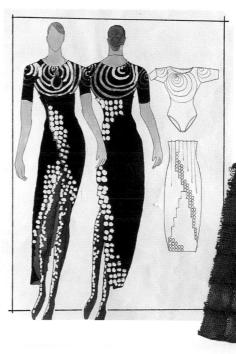

unit 23: showcase

Designers vary their illustration style from project to project, building up a portfolio that contains a range of presentations, each one telling a different story both in terms of design and style of presentation. This demonstrates versatility and ensures that each project has its own distinct personality. The illustrations can be made using pen and ink, paint, collage, felt-tip pen, computer scanning—anything goes, so long as the illustration style contributes to the overall theme and communicates the designer's vision.

The creation of effective presentation boards is a detailed and time-consuming process. Plenty of time should be allowed: it is easy to get bogged down in the rough planning stage and end up rushing the final presentation, which will spoil the impact of the ideas when they are shown to potential clients or employers. A good presentation, like those illustrated here, displays the garments in a way that is attractive but also easy to interpret. The golden rule is simplicity. Items such as

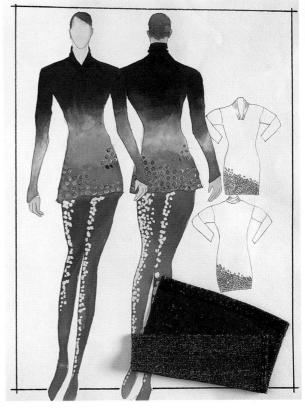

ৰ 🛦 A dramatic style

These final presentations are simple, bold, and graphic, playing with silhouette and transparency. An alternative approach would have been to include more decorative and fabric detail.

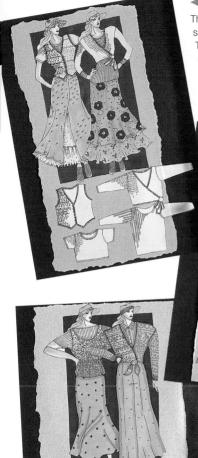

Avoiding ambiguity

These creative illustrations are supported with flat technical drawings. The two styles of illustration support each other to give maximum clarity to the presentation.

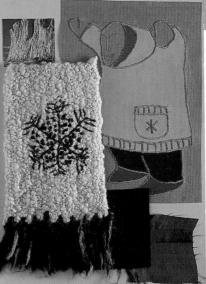

Having fun

A children's-wear range might inspire a lighthearted illustration style that is concerned with fun rather than realism.

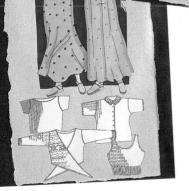

Depicting fabrics

If original fabric designs are an important feature, samples should be included in the presentation. To avoid overwhelming illustrations of the garment silhouettes, the detail of the textiles could be displayed as swatches, either separately on the same board or on a different board.

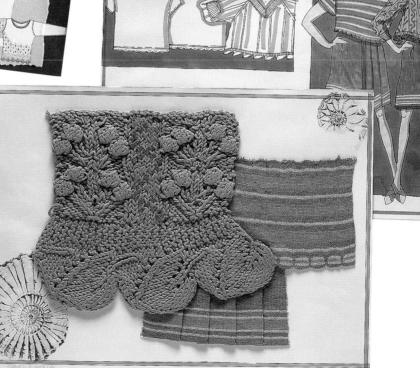

umit 24

Presenting with flair

 Λ /hen deciding how to present your work, think back to whatever it was that first sparked your excitement about your theme. Your creativity does not have to be impeded by the need for clear and simple presentation. It is true that you should not overpresent your work so that the style of presentation becomes more powerful than the content. However, if you maintain a careful balance, a creative presentation will add to the overall impact of your design project. This final unit is intended to maximize your creativity in presentation—encouraging you to think not only about your drawing styles but also about the poses of the figures, the use of fabrics, colors, lettering, and decoration, the possibilities offered by different media. and the overall effect of the board. Your aim should be to channel all these aspects into the creation of presentations that will communicate your vision to colleagues, teachers, employers, and clients.

the project

Gather together all the elements of a previous design project. These will include the original sources of inspiration, your primary and secondary research, your sketchbook work, roughs, working drawings, final illustrations, and any photography. Considering this material and the nature of your design theme and your target audience, decide on the most appropriate method of final presentation. Pick out your key designs and present them in a manner that supports and promotes your fashion ideas.

the objective

- Create original boards that reflect your unique style.
- Strengthen the impact of your design ideas by using complementary methods of presentation.
 - Tailor your presentation to your target audience.
- Balance the clear communication of your ideas with exciting and creative methods of presentation.

the process

Find a large table or a clean floor space that will allow you to lay out lots of images. Group them together so that you are able to see your initial inspiration, roughs, and final illustrations side by side. Stand back and take a critical look at your developments. What was it that attracted you to this topic, and how have you expanded upon these ideas as you worked on the project? Is the theme still strongly reflected or have your designs evolved away from your starting point? Start to identify elements that could be used for presentation, such as interesting motifs, color combinations, textures,

▲ Strengthening the designs

These presentation boards in the style of 1940s film posters reinforce the impact of the glamorous tailoring of the designs themselves.

styles of lettering, garment styling ideas, methods of photography, and types of paper.

Decide on how you want to present your ideas. If your work has a glamorous feel inspired by film stars, your drawings could be supported with some exciting styles of photography, perhaps using dramatic lighting or

Menn Coldina Marer action

black-and-white film. Do not slavishly copy existing styles, no matter how authentic they are to your research, but reinvent your inspiration in a modern context.

Always ask yourself whether potential clients will be able to relate to your methods of presentation. Buyers working in a commercial arena might be alienated

SELF-CRITIQUE

- Have you been able to balance creativity with clear presentation of your design ideas?
- Does your style of presentation support and add to your garment designs?
- Have you used a style that looks fresh and modern?
- Have you considered your target audience?

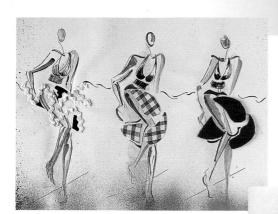

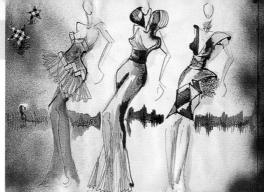

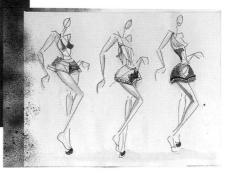

Creating excitement

Even the pose of your figures can reflect your source. The "showgirl" stance of these figures reinforces the glamorous theme and lends a feeling of movement and celebration to the pictures.

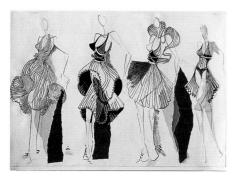

by a very dramatic style of presentation, whereas a client with whom you are working on a bridal collection will have a romantic expectation of both the designs and the style of presentation.

Remember that you are trying to achieve a balance between communicating your design concepts with clarity and creating a visually exciting presentation. You should also choose a style of illustration appropriate to your theme, as described in Unit 23 (pages 130-133). Make sure that

the arrangement on your board is not overcrowded (for some useful practical tips see Unit 22, pages 126-129). If necessary you will have to select which items to include, prioritizing garment illustrations, working drawings, and fabric swatches.

SEE ALSO

- Practicalities of presentation, p. 126
- Choosing a presentation style, p. 130

Reinforcing your ideas

A "showgirl" theme will inspire a dramatic approach to silhouette, fabric choice, and styling—and this can be given greater authority with a dramatic presentation style.

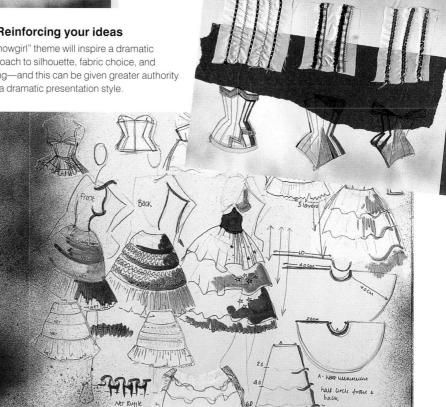

Unit 24: showcase

A lthough it is important not to overembellish a presentation so that it has more impact than the garment designs themselves, a carefully prepared presentation will support and strengthen the illustrations. These presentations underline the glamor of designs based on the worlds of film and theater in various ways. Dramatic photography and the use of a billboard poster style suggest a film-star theme, and sketches reminiscent of costume design, the use of spray paint and star motifs, and the portrayal of showgirl fabrics like satin, boned silk, diamanté embroideries, laces, and feathers all evoke the theater. Marilyn Monroe's famous billowing-skirt pose is reproduced in one set of drawings; in another, Judy Garland's ruby slippers add a witty touch. If stuck for ideas when presenting designs, it is always useful to think back to the original source. Garments inspired by a beautiful garden, for example, might well be photographed laid on flowers or hanging among branches. So long as the presentation supports the designs, there is always opportunity to be creative.

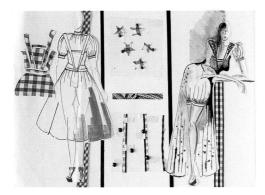

◄ ▼ Evoking the inspiration

The fabric used here is evocative of the *Wizard* of *Oz* inspiration.

Restating the source

The Marilyn Monroe-style poses of these illustrations support the cinematic theme wonderfully, adding authority to the concept.

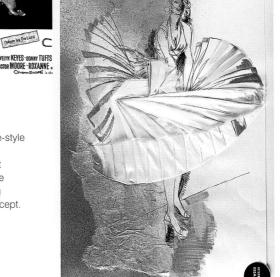

LES K FEIDMAN CROUP PRODUCTIONS

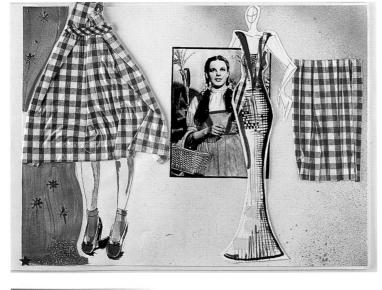

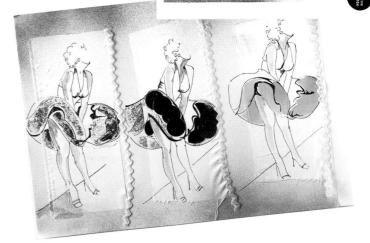

Elaborating on the details

Fabrics, trims, and other details can make great presentation ideas—used as an edging on a board, perhaps, or to decorate the cover of a sketchbook—so long as they do not detract from the designs.

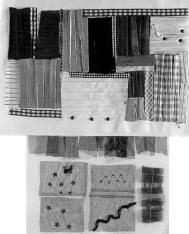

Presenting a sketchbook

Even the cover of this sketchbook was embellished to coordinate with the design story.

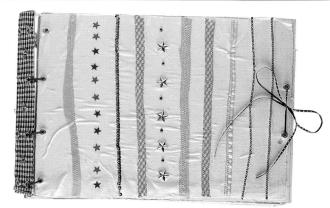

Creative freedom

If illustrations become rather painterly, as here, they can be supported with working drawings—allowing scope for both clarity and creativity.

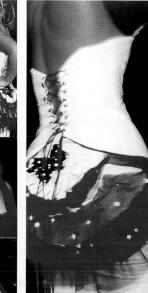

Fashion photography

Bold photography, using angled shots, accentuated poses, and creative cropping, will reinforce a flamboyant design.

Fashion resources

Courses in fashion design

The following list comprises only a very small selection of the many colleges and universities worldwide with departments of fashion design. Whether you are looking for an evening class or for full-time tuition in an undergraduate or postgraduate degree, the huge variety of options available should mean that you have no problem in finding the course that's right for you.

AUSTRALIA

Royal Melbourne Institute of Technology G.P.O. Box 2476V Melbourne Victoria 3001 t.: (++61) 3 9925 2000 www.rmit.edu.au

CANADA

International Academy of Design and Technology 1253 McGill College Ave., 10th fl. Montreal Quebec H3B 2Y5 t.: (++1) 514 875 9777 www.internationalacademy.ca

Montreal Superior Fashion School La Salle College 2000 Ste-Catherine St. W. Montreal Quebec H3H 2T2 t.: (++1) 514 939 2006 www.clasalle.qc.ca

DENMARK

Copenhagen Academy of Fashion Design Nørrebrogade 45, 1. sal 2200 Copenhagen N. t.: (++45) 33 328 810 www.modeogdesignskolen.dk

FRANCE

Creapole 128 r. de Rivoli 75001 Paris t.: (++33) 1 4488 2020 www.creapole.fr

Esmod Paris 16 blvd Montmartre 75009 Paris t.: (++33) 1 4483 8150 www.esmod.com

Parsons Paris 14 r. Letellier 75015 Paris t.: (++33) 1 4577 3966 www.parsons-paris.pair.com

ITALY

Domus Academy Via Watt 27 20143 Milano t.: (++39) 2 4241 4001 www.domusacademy.it

Polimoda via Pisana 77 I-50143 Firenze t.: (++39) 55 739 961 www.polimoda.com

NETHERLANDS

Amsterdam Fashion Institute Stadhouderskade 55 1072 AB Amsterdam t.: (++31) 20 570 2500 www.amfi.hva.nl

SPAIN

Institucion Artistica de Ense-anza c. Claudio Coello 48 28001 Madrid t.: (++34) 91 577 17 28 www.iade.es

U.K.

University of Brighton Mithras House Lewes Rd Brighton BN2 4AT t.: (++44) (0)1273 600 900 www.brighton.ac.uk

Central St Martin's College of Art and Design Southampton Row London WC1B 4AP t.: (++44) (0)20 7514 7000 www.csm.linst.ac.uk

De Montfort University The Gateway Leicester LE1 9BH t.: (++44) (0)116 255 1551 www.dmu.ac.uk

Kingston University Cooper House 40–46 Surbiton Rd Kingston upon Thames Surrey KT1 2HX t.: (++44) (0)20 8547 7053 www.kingston.ac.uk University of Lincoln Admissions & Customer Services Brayford Pool Lincoln LN6 7TS t.: (++44) (0)1522 882 000 www.lincoln.ac.uk

London College of Fashion 20 John Prince's St. London W1G 0BJ t.: (++44) (0)20 7514 7344 www.lcf.linst.ac.uk

University of the Arts London 65 Davies St. London W1K 5DA t.: (++44) (0)20 7514 6000 www.linst.ac.uk

University of Manchester Institute of Science and Technology PO Box 88 Manchester M60 1QD t.: (++44) (0)161 236 3311 www.umist.ac.uk

Nottingham Trent University Burton St. Nottingham NG1 4BU t.: (++44) (0)115 941 8418 www.ntu.ac.uk

Ravensbourne College of Design and Communication Walden Rd Chislehurst Kent BR7 5SN t.: (++44) (0)20 8289 4900 www.ravensbourne.ac.uk Royal College of Art Kensington Gore London SW7 2EU t.: (++44) (0)20 7590 4444 www.rca.ac.uk

The Surrey Institute of Art and Design University College Falkner Rd Farnham Surrey GU9 7DS t.: (++44) (0)1252 722 441 www.surrart.ac.uk

U.S.A.

American Intercontinental University (Buckhead) 3330 Peachtree Rd, N.E. Atlanta, GA 30326 t.: (++1) 800 955 2120 www.aiubuckhead.com

American Intercontinental University (Los Angeles) 12655 W. Jefferson Blvd Los Angeles, CA 90066 t.: (++1) 888 522 2255 www.aiula.com

Brooks College of Fashion 4825 E. Pacific Coast Hwy Long Beach, CA 90804 t.: (++1) 562 597 6611 www.brookscollege.edu

Cornell University 170 Martha Van Rensselaer Hall Ithaca, NY 14853 t.: (++1) 607 254 4636 www.cornell.edu Fashion Careers of California College 1923 Morena Blvd San Diego, CA 92110 t.: (++1) 619 275 4700 www.fashioncollege.com

Fashion Institute of Design and Merchandising (Los Angeles) 919 S. Grand Ave. Los Angeles, CA 90015-1421 t.: (++1) 213 624 1201 www.fidm.com

Fashion Institute of Design and Merchandising (San Diego) 1010 2nd Ave. San Diego, CA 92101-4903 t.: (++1) 619 235 2049 www.fidm.com

Fashion Institute of Design and Merchandising (San Francisco) 55 Stockton St. San Francisco, CA 94108-5829 t.: (++1) 415 675 5200 www.fidm.com

Fashion Institute of Design and Merchandising (Orange County) 17590 Gillette Ave. Irvine, CA 92614-5610 t.: (++1) 949 851 6200 www.fidm.com

Fashion Institute of Technology Seventh Ave. at 27 St New York NY 10001 t.: (++1) 212 217 7999 www.fitnyc.suny.edu International Academy of Design and Technology (Chicago) 1 North State St., Suite 400 Chicago, IL 60602 www.iamd.edu

International Academy of Design and Technology (Tampa) 5225 Memorial Highway Tampa, FL 33634 www.academy.edu

Katherine Gibbs School 50 W. 40th St. New York NY 10018 www.gibbsny.com

Parsons School of Design 66 Fifth Ave., 7th Floor New York, NY 10011 t.: (++1) 212 229 8590 www.parsons.edu

School of Fashion Design 136 Newbury St. Boston MA 02116 t.: (++1) 617 536 9343 www.schooloffashiondesign.org

University of North Texas School of Visual Arts Office of Undergraduate Admissions P.O. Box 305100 Denton Texas 76203-5100 t.: (++1) 940 565 2855 www.art.unt.edu

Fashion designers online

If you are stuck for inspiration or want to bring yourself up to date on forthcoming trends, why not check out the web sites belonging to the top fashion designers? Here are just some of the good sites:

www.agnesb.fr www.alexandermcqueen.co.uk www.annasui.com www.antoniandalison.co.uk www.apc.fr www.balenciaga.com www.betsevjohnson.com www.bless-service.de www.bruunsbazaar.com www.burberry.com www.celine.com www.chanel.com www.christian-lacroix.fr www.coupny.com www.daniellenault.com www.delphinepariente.fr www.dior.com www.dolcegabbana.it www.donnakaran.com www.driesvannoten.be www.elspethgibson.com www.emiliopucci.com www.fendi.it www.ahost.co.uk www.gianfrancoferre.com www.giorgioarmani.com www.giovannivalentino.com www.givenchy.com www.gucci.com www.helmutlang.com www.hugo.com www.isseymiyake.com www.jaeger-lecoultre.com www.jaredgold.com www.jasperconran.com

www.jeanmuir.co.uk www.johngalliano.com www.jpgaultier.fr www.karenwalker.com www.katespade.com www.kennethcole.com www.kenzo.com www.lacoste.com www.llovdklein.com www.lucienpellat-finet.com www.marciacobs.com www.michaelkors.com www.michikokoshino.co.uk www.moschino.it www.oscardelarenta.com www.pacorabanne.com www.patriciafield.com www.paulsmith.co.uk www.peopleusedtodream.com www.pleatsplease.com moo.olog.www www.prada.com www.redblu.com www.robertocavalli.it www.seanjohn.com www.soniarykiel.com www.stellamccartney.com www.tommy.com www.versace.com www.viviennewestwood.com www.vuitton.com www.yohjiyamamoto.co.jp www.ysl.com

Glossary

"all-ways" print A print with motifs that are not aligned in any one particular direction: the fabric will work in the same way whichever way up it is.

art deco A design style, popular between the two World Wars, that was characterized by simplicity, bold outlines, geometrical order, and the use of new materials such as plastic.

bias cutting Cutting fabric with the pattern pieces placed at a 45-degree angle to the selvages and the grain.

brief The client's, employer's, or tutor's instructions to a designer, setting the parameters of a design project.

clip-art images Copyright-free images available through the Internet.

collage An image created by sticking items (such as paper cuttings or pieces of cloth) to a surface. From the French *coller* (to glue).

collection The group of garments produced each season by a designer. Usually these items have certain features in common, such as color, shape, and pattern.

color palette A limited selection of colors used by a designer when creating a collection to ensure a cohesive color scheme.

color theming Giving the items in a collection a common identity through the repeated use of certain colors.

colorway The choice of colors used in an individual piece. Changing the colorway can alter the look of a garment dramatically.

cropping Trimming an illustration to alter the focus of the composition (removing an unwanted area of empty space, for example) or to remove tattered edges.

customer profile Information about the lifestyle of the target customer—such as age, economic status, and occupation—that guides a designer in creating commercially viable collections.

dry-mounting Placing adhesive backing onto an illustration and then heating in order to adhere it to a board.

grain The fabric grain is the direction of the woven fibers, either lengthwise or crosswise. Most dressmaking pieces are cut on the lengthwise grain, which has minimal stretch; when bias cutting, pieces are placed diagonally to the grain.

layout The composition of the illustration on the page. A bold layout, which fills the page and makes the design statement with confidence, is often the most successful approach.

mixed media A combination of different media within the same image. Possible media include color pencils, oil pastels, crayons, gouache, watercolor paints, pen and ink, or even a computer or photocopier.

mood board A board displaying inspirational research, current fashion images, fabric swatches, and color palettes. It should encapsulate the most important themes from the research and act as a focus during the creation of the designs.

"negative space" Part of the illustration left deliberately blank so that viewers, who might have expected these areas to be filled in, will read the invisible lines through the white space.

"one-way" print A print where the motifs are aligned in one direction. More expensive to use for making garments than "all-ways" prints since extra fabric is required to align the print correctly. **Pantone color chips** Individually numbered shades, supplied in color reference books. The numbered shades are recognized throughout the international fashion industry.

portfolio A case used for storing, transporting, and displaying illustrations.

presentation board A light foam board available in various sizes from art supply stores. Used for presenting work to tutors, employers, and clients.

range Used interchangeably with "collection" to describe the group of garments produced each season by a designer. "Range" has also more specifically commercial overtones, indicating a selection of coordinating garments that offers maximum choice to the customer within the parameters of the range.

roughs The quick unconstrained sketches that a designer uses to "think out loud on paper," developing a research idea into a range of designs.

silhouette The outline shape of a complete ensemble.

target customer The person who is likely to wear the designs produced for each project. A designer should construct a profile of the target customer in order to ensure that the garments are commercially focused.

target market The range of target customers that a retailer aims to satisfy.

working drawing The representation of a garment as it would look laid out flat, rather than drawn on a figure. Used to convey precise information about the construction, trims, finishes, and any other details of the pieces. Also known as "flats," or technical or specification drawings.

Index

Page numbers in *italics* refer to captions

Α

ABBA 25 abstraction 38, 45 accessories 101, 121 adhesive 126, 127 Adobe Photoshop 40 "all ways" print 34, 35 Ancient Egypt, inspiration from 16, 18-19, 18, 19 antique textiles, inspiration from 25 architecture, inspiration from 14, 15, 20, 20-21, 21, 22, 22, 23 art, inspiration from 6, 34, 34-36, 35, 36, 44, 45 art deco style 15, 20 art nouveau patterns 41

В

back view 78, 85 balance 75, 75 bias, cutting on the 34, 109 borders: use in presentation 129 bridalwear 88, 98, 135 budget 30, 92, 98–99, 100

С

Cadillac *14* Chalayan, Hussein: skirt 8 children's-wear 133 Chrysler Building *14*, 15, 20 clip-art images 34 clutter, avoiding 74 collaboration *121*, 122, *122*

D

in life drawing 62, 63, 64 collection, creating a 82, 82, 83, 84, 84, 86 color: chips 104, 105; see also Pantone chips combinations 27, 104, 105.106 in life drawing 60 matching 31 in presentation 128 simultaneous application of 70, 71.72 swatches 104 theming 29 color palette 17, 26, 27, 29, 40, 45, 72, 94, 102, 102, 104, 106, 107 changing 106 for a collection 86 consistent 18, 19, 68 creating 67, 105 limited 18, 23, 36, 60, 64, 104 of a painting 34 colorways, variant 34, 35, 35, 36, 37 Conran, Jasper: collection 88 coordinating garments see mix-and-match range crochet 108, 109 cropping 49, 74, 75 customer: profile 30, 92 target 26, 27, 28, 45, 84,

90, 92-93, 94, 96, 98,

100, 100

taste 93, 94, 95, 96

collage 45, 57, 65

daywear project 88-91 decoration see embellishment design: brief 92-93 fabric 40-42, 43 lavout 74-75, 75 print 6, 34, 34-35, 35, 36. 37. 46 devoré velvet 42 drawings: figure 50-51; folded-paper method 52, 52-53, 54, 54 fixing 126 life 51, 58, 58-59, 59, 60; collage 62, 63, 64 roughs 82, 84-85, 86, 88, 105, 106 working ("flats") 83, 84, 85. 114-115. 115. 116, 116-117, 118, 118, 119, 133: in presentation 125, 125, 126, 127, 130, 131, 132, 135, 137 dry-mounting 126 Dufy, Raoul 6, 34, 36, 36 dveina 40

Ε

Easter Island statues 14 elongation in fashion illustration 50, 51, 52, 54 embellishment 32, 40, 110, 118 cost of 92 embroidery 40, 44–46, 47, 98, 130 inspiration for 24 machine 45, 45, 47 site of 45 end-of-year show 8, 121, 122, 123 ethnic styles 15, 15, 32 eveningwear 88, 98, 99 experimentation 56–57, 70, 72

F

fabric 102 bias cut 34, 109 design 40-42, 43 draping 6, 102, 102, 103, 108, 110, 120 grouping 103 manipulation 108 properties of 108 structuring 108-109, 109.110 swatches 42, 43, 103, 135 textured 114 fashion illustration 51, 76 figure drawing 50-51 folded-paper method 52. 52-53. 54. 54 film see movies, inspiration from fixing drawings 126 flats 83, 84, 84, 85, 114, 115. 133 see also working drawings

G

garment: construction 89, 108–109, 110, 114, 115, 116, 117, 118, 119 mocking up 120 Ghost design 92 graphics material 34, 35, 36, 37 graveyard, inspiration from 40, 42, 43 Guggenheim Museum 20

Н

hair, representing 67, 68, 69 Hawaiian beach shirt 74, 76, 76–77, 78 henna hand tattoos 30, 37 Hilfiger, Tommy 15 Hindu gods and goddesses 30

I

illustration style 42, 43, 66, 124–125, 130–131, 132, 135 India, inspiration from 30, 30–32, 31, 32, 33 insect wing 38, 38 Internet 15 *see also* web sites

J

Jackson, Betty: collection 82

Κ

Kandinsky, Wassily 34 Klimt, Gustave 44, *44*, 46 knitting 40, 46, *46*, *47*, 108, 109, 110 knitwear designs 96, 110

L

La Boca, Buenos Aires 20 lacework, inspiration for 20, 24 layers 39, 39, 98, 130 ripped 20 layout 74–75, 75 Leaning Tower of Pisa 20, 20 Leonardo da Vinci 50 life drawing 51, 58, 58–59, 59, 60 collage in 62, 63, 64 lifestyle profile 92, 93, 94, 95, 97, 98 lingerie 98 Lycra 15

Μ

magazine cuttings 26, 26, 27. 28. 57. 82 Matisse, Henri 34 media: experimenting with 56, 56-57, 70 in life drawing 60 mixed 70, 71, 72 Miró, Joan 34, 35 mix-and-match range 88, 88.89.90 Mondrian, Piet 34, 34, 36.36 mood board 25, 26-27, 27, 28, 28, 29, 40, 41, 86, 100, 104, 105 motif(s): illustrating 77, 78 repeated 34, 35 see also pattern(s) mounting 126, 127 movement of human body 51.53 movies, inspiration from 15. 134. 137. 137 "muse" 92 museums, inspiration from 15, 16, 16-17

Ν

neckline *117* "negative space" *65,* 67, *69*

0

observational skills 68, 76 oil pastels 70, 71, 72, 72 "one-way" print 34, 35 outdated styles, inspiration from 25 overall image 66, 67, 68, 72, 73, 86, 86, 87, 117

Ρ

packaging, inspiration from 25 page format 75 Pantone chips 27, 104, 105 papyrus 17 past, inspiration from 14 pattern(s): repeating 41, 45 simplified 41, 44, 45, 45 see also motif(s) pencil 70 photography 31, 40, 40, 44, 45, 66, 67 of architecture 21, 21 black-and-white 40 close-up 24 digital 40, 122 in fabric structuring 108 fashion 33, 137 of garments 120, 122.122 in presentation 126 for working drawings 117 Picasso, Pablo 34 pleating 108, 120 portfolio 118, 122, 124,

124, 131, 132 pose: exaggerated 58, 59.60 repeated 69 presentation 124-125, 125, 126-127, 128, 128, 133 board 104, 118, 124, 124, 127, 132 complex 128 creative 9, 134, 134 elements 131 inspiration from source 6.136 style 8, 130, 130-131, 131, 132, 134 themed 135, 136 print design 6, 34, 34-35, 35, 36, 36, 37, 46 coordinating 34 illustrating 76, 77, 78, 78.79 printing 40 proportion(s) 25, 41, 86, 115, 117, 118, 119 color 105, 106, 107 of human body 50, 50-51, 51, 52, 52, 53, 54, 55

R

range planning *66*, 68, 83, 88, 89, 90, *90*, *91* roughs 82, 84–85, 86, 88, 105, 106

S

sailing wear 15 scale 16, 37, 38, 41, 119 of decoration 130 scarf project 34–36, 37 scrapbook *31*, 82

sculpture, inspiration from 28 seaside, inspiration from 28 seasons 27, 28, 92, 98, 100, 102 colors 26, 29 variations 44 shape 25, 40, 98, 102, 108, 109 see also silhouette silhouette 9, 42, 43, 86, 87, 102, 110, 117 in presentation 128, 132 theme 31 simplification of pattern 41, 44, 45, 45 sketchbook 6, 137 in portfolio 125, 125 skirts for men 92 skyscraper windows, inspiration from 14, 22, 22 source 17, 42, 136, 136 analyzing 108 natural 39 specification drawings 119 spontaneity, developing 56-57 sportswear 98, 99, 108 structured 15, 15 storage 124 street art, inspiration from 25 stylization 53, 54, 55, 68.68 swatches: color 104 fabric 27, 42, 43 paint 26, 27 in presentation 126, 127,

127, 132, 133

swimwear 88, 98, 98 Sydney Opera House 20

Т

target customer 26, 27, 28, 45, 84, 90, 92–93, 94, 96, 98, 100, *100* target market 93 templates *47* texture *17*, 25, 40, 108, *114*, *115* tracing 84, *85*, 117, 118 trends 27, 28, 92 color 102 in fabric structuring *109*

V

Van Noten, Dries: skirt for men 92 Versace collection 88 vintage dress, inspiration from 28 Vitruvian Man (da Vinci) 50 volume 25, 108, 110, 111

W

wardrobe, drawing from own 66–67, 116, 117 watercolor 70, 72 web sites, fashion 27, 102 working drawings 114–115, *116*, 116–117, 118, *118* in presentation 125, *125*, 126, 127, 130, 131, 132, 135, *137 see also "*flats" workwear 90, *90*, 101

Credits

Quarto would like to thank and acknowledge the following for permission to reproduce their pictures:

(Key: t top; b bottom; l left; r right; c center)

Caroline Tatham: pp.1, 2(l), 3(t), 4(tc,tr,b), 5(l,r), 6(t), 7(b), 8(l), 9(tr), 11, 24(bl,tr), 25(cr), 27, 28, 29, 38(br), 39(br), 40, 41, 42, 43, 44(tr,b), 45, 46, 47, 48, 49, 74(l), 75(t), 82(r), 83, 84, 85, 86, 87, 89, 90, 91, 93(bc), 94, 95, 96, 97, 99(tl,bc), 100, 101, 102, 103, 104, 105, 106, 107, 108, 109, 110, 114, 115, 116, 117, 118, 119, 120, 121, 122, 123, 125(tc,tr), 127, 128(l), 129, 130, 131, 132, 133. Gamma/Kambouris Dimitrios: 88(t). Gamma/ Simon-Stevens: 13, 34. Gamma/Van der Stockt Laurent: 81. Heritage Images/British Museum: 17(br). Heritage Images/Corporation of London Libraries and Guildhall Art Gallery: 16(b). Heritage Images /National Motor Museum: 14(I). Holly Marler: pp.9(tl), 39(tc,br), 111, 125, 134, 135, 136, 137. Julian Seaman: pp.2(c,r), 3(b), 4(tl,c), 5(cr), 6(bl), 7(t), 15(cl), 35, 36, 37, 50, 51, 52, 53, 54, 55, 56, 59, 60, 61, 63, 64, 65, 66, 67, 68, 69, 70, 71, 72, 73, 74(r), 75(b), 77, 78, 79, 125(tl), 128(c,r). Roisin Dunn: pp.17(lt,c,b), 18, 19. Saskia Mullins: pp.6(br), 74(c), 125(b). Sherina Dalarmal: pp.31(b), 32, 33. Timothy Lee: pp.14(tr), 21, 22, 23. Topfoto.co.uk: 8(r), 9(b), 15(tl,tr,cr), 25(c,b), 31(t), 44(tl), 82(l), 88(b), 92, 113. www.vintagehawaiianshirt.net: 76(t).

All other photographs and illustrations are the copyright of Quarto Publishing plc. While every effort has been made to credit contributors, we would like to apologize in advance if there have been any omissions or errors.

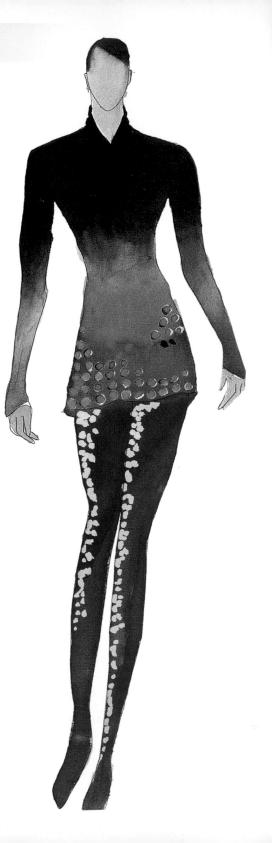